Modeling the Figure in Clay

Also by Bruno Lucchesi and Margit Malmstrom

Terracotta: The Technique of Fired Clay Sculpture
Modeling the Head in Clay

Modeling the Figure in Clay

Sculpture by
BRUNO LUCCHESI

Text and Photographs by
MARGIT MALMSTROM

WATSON-GUPTILL PUBLICATIONS/NEW YORK

First published 1980 in the United States and Canada by Watson-Guptill Publications,
a division of Billboard Publications, Inc.,
1515 Broadway, New York, N.Y. 10036

Library of Congress Cataloging in Publication Data
Lucchesi, Bruno, 1926-
 Modeling the figure in clay.
 Includes index.
 1. Human figure in art. 2. Modeling.
I. Malmstrom, Margit. II. Title.
NV1932.L79 1980 731.4'2 79-28265
ISBN 0-8230-3097-0

Manufactured in U.S.A.

First Printing, 1980

4 5 6 7 8 9/86 85

*This book is dedicated to
every sculptor who ever transformed
a humble ball of clay into that miracle
of beauty, the human form.*

The author wishes to thank
Jennifer and Jim Collins.
They know why.

CONTENTS

ABOUT THE ARTIST

Bruno Lucchesi was born in 1926 in the village of Fibbiano, high in the mountains of Tuscany, in the province of Lucca, Italy. His family, like all the villagers, were farmers and shepherds; they raised the food they ate and made the clothes they wore, and as a boy Bruno took his turn on the steep mountainsides to tend the sheep. But young Lucchesi's artistic gifts were early recognized and he went to study art in Lucca and later in nearby Florence. When not in school, Bruno prowled the streets and museums of Florence and learned by heart the lessons of the greatest masters of Renaissance art. He was especially drawn to the architecture of Brunelleschi and Alberti, the sculpture of Tino di Camaino and Donatello, and the work of the Mannerist painters Pontormo and Il Rosso.

In 1957 Lucchesi came to the United States, where his sculpture was a radical departure from what was being seen at the time. His work springs directly from the nourishing Tuscan soil and the long tradition of Italian Renaissance art. It is realistic, approachable, understandable, and executed with consummate skill. It is beautiful in its grace of line and expression. And, in addition, it has an intimacy and a sense of pathos and humor that are completely contemporary. The excellence of Lucchesi's work was instantly recognized, and over the years his sculptures have been added to the collections of the Whitney Museum of American Art, The Brooklyn Museum, the Dallas Museum of Fine Arts, The John and Mabel Ringling Museum of Art in Sarasota, Florida, The Pennsylvania Academy of the Fine Arts, and the Hirshhorn Museum and Sculpture Garden, Washington, D.C., among others. His work is also well represented in many private collections, among them the Albert A. List Collection. He has received awards from the National Academy, which elected him Member in 1975, the National Arts Club, and the Architectural League, and he was a Guggenheim Fellow in 1962–63.

Lucchesi is perhaps best known for his smaller figures and his genre sculptures, but he also does many major commissioned pieces that are lifesize and larger. Among these are his heroic-size bust of the poet Walt Whitman, installed in 1971 in Arrow Park, Monroe, New York, and—most recently—a heroic-size statue of Sir Walter Raleigh commissioned by the city of Raleigh, North Carolina, installed in 1976.

Lucchesi lives in New York, where he takes time out from creating new work to teach packed classes at the New School and the National Academy.

The sculpture of Bruno Lucchesi may be seen on permanent display at the Forum Gallery in New York, which has been his exclusive dealer since 1960.

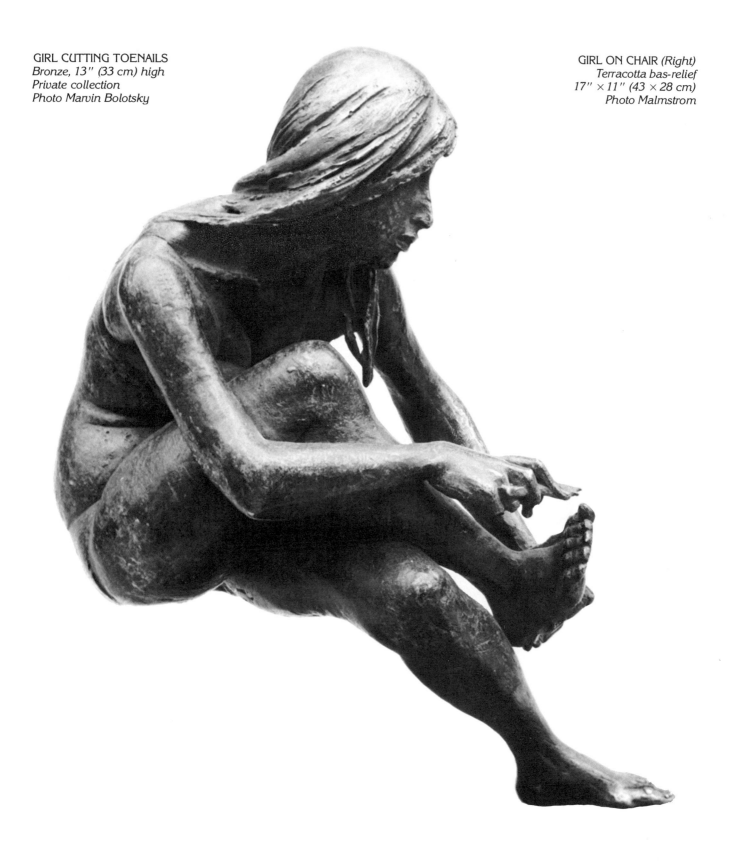

GIRL CUTTING TOENAILS
Bronze, 13" (33 cm) high
Private collection
Photo Marvin Bolotsky

GIRL ON CHAIR *(Right)*
Terracotta bas-relief
17" × 11" (43 × 28 cm)
Photo Malmstrom

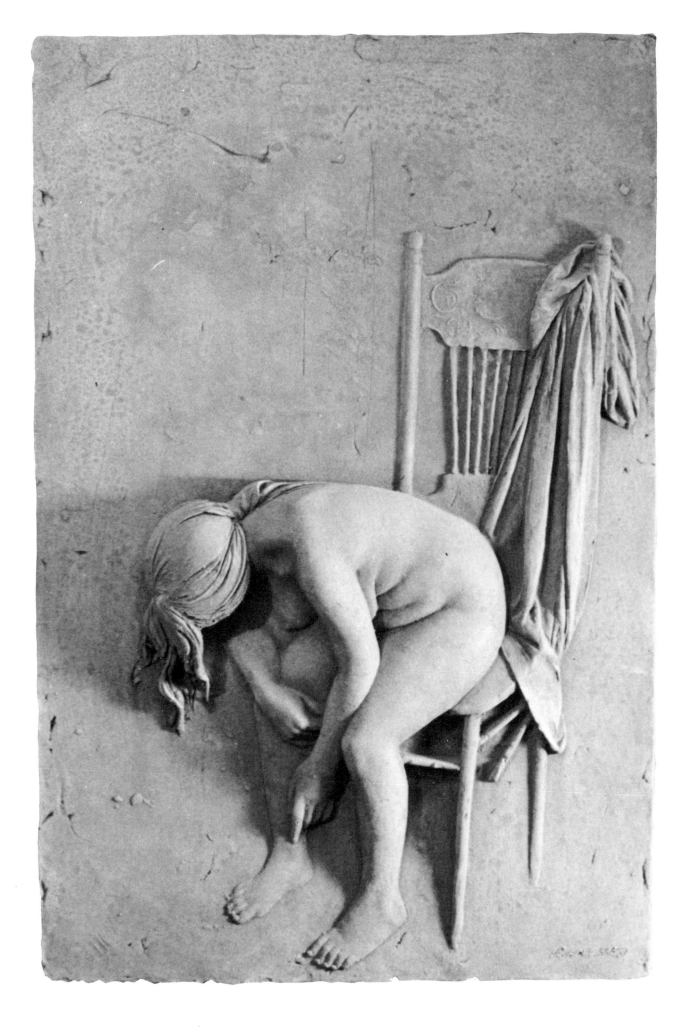

AT THE FOUNTAIN
Terracotta, 18" (46 cm) high
Photo Marvin Bolotsky

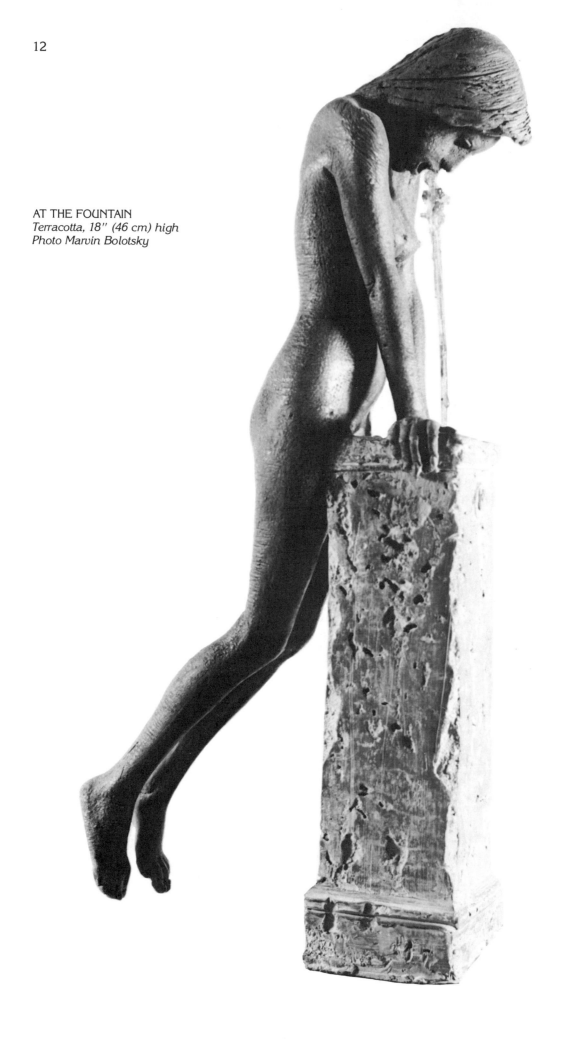

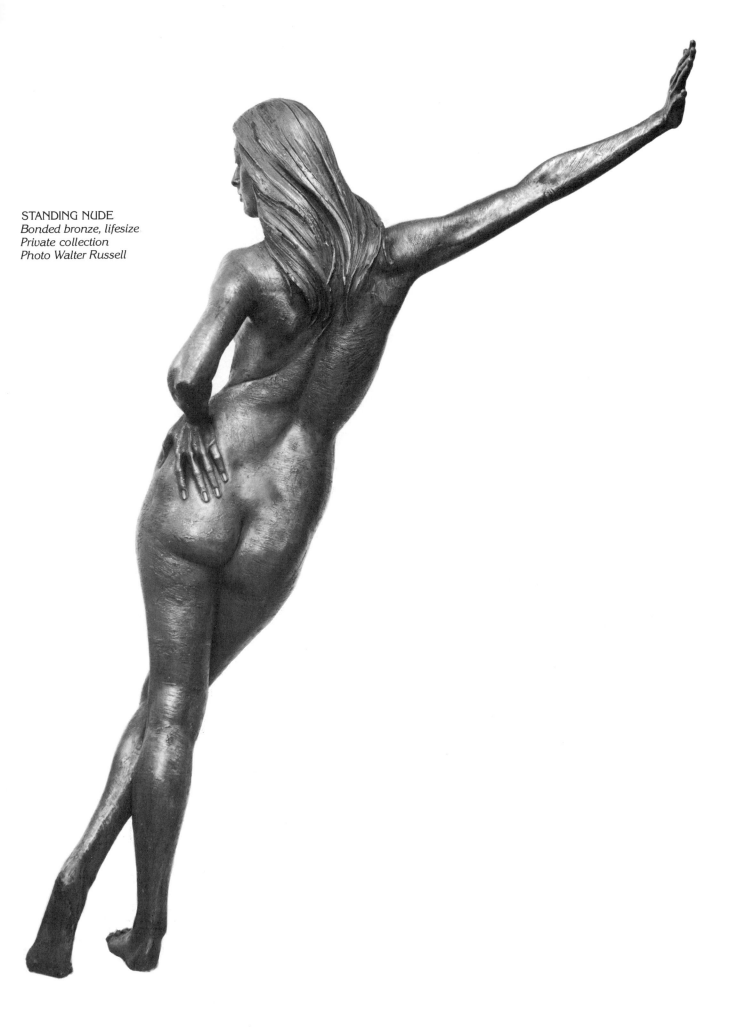

STANDING NUDE
Bonded bronze, lifesize
Private collection
Photo Walter Russell

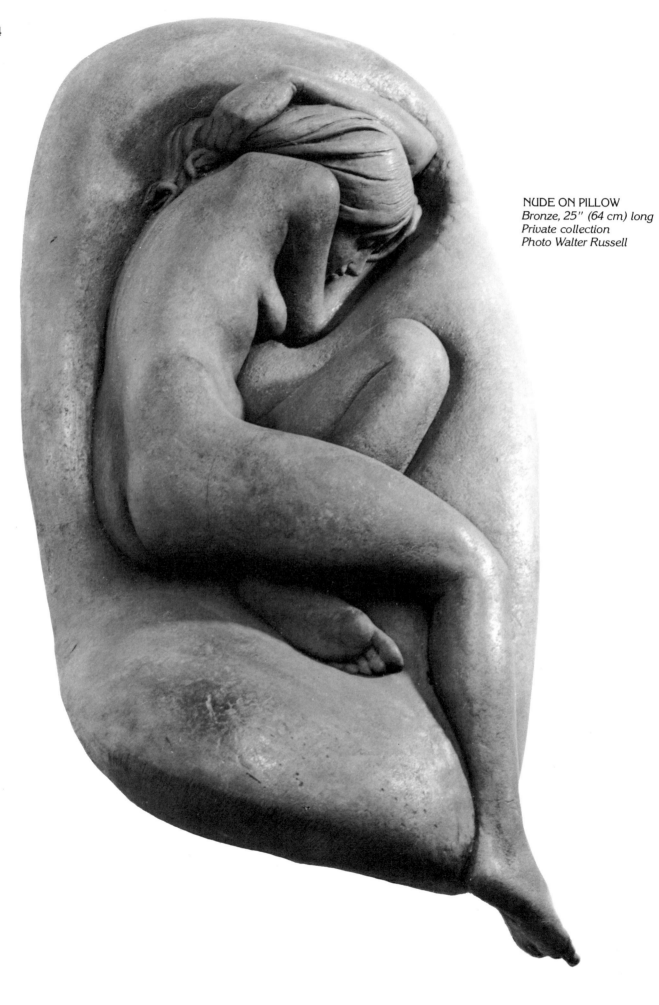

NUDE ON PILLOW
Bronze, 25" (64 cm) long
Private collection
Photo Walter Russell

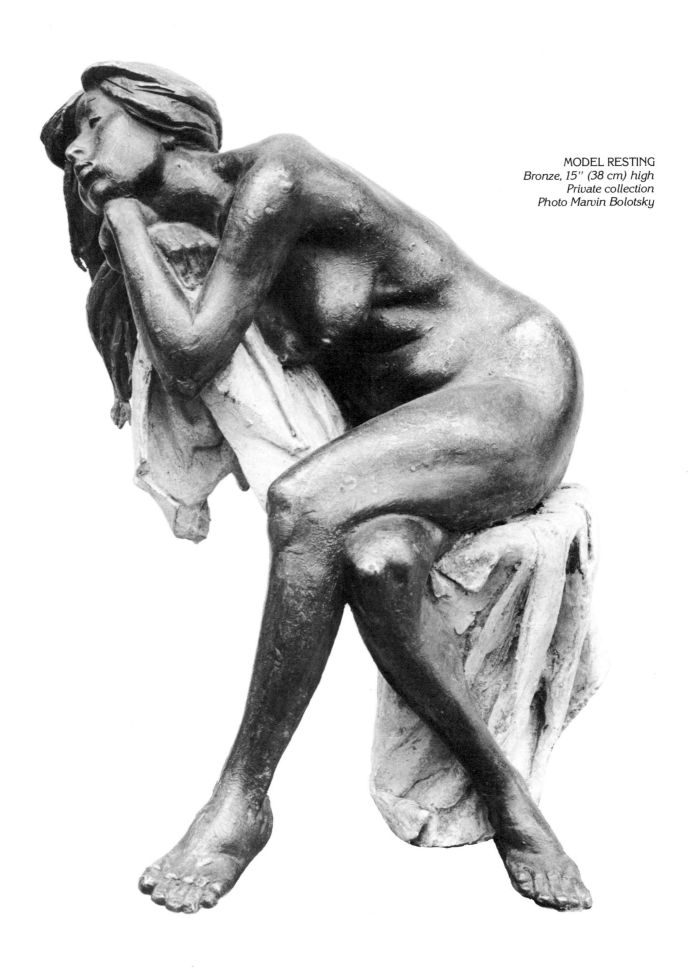

MODEL RESTING
Bronze, 15" (38 cm) high
Private collection
Photo Marvin Bolotsky

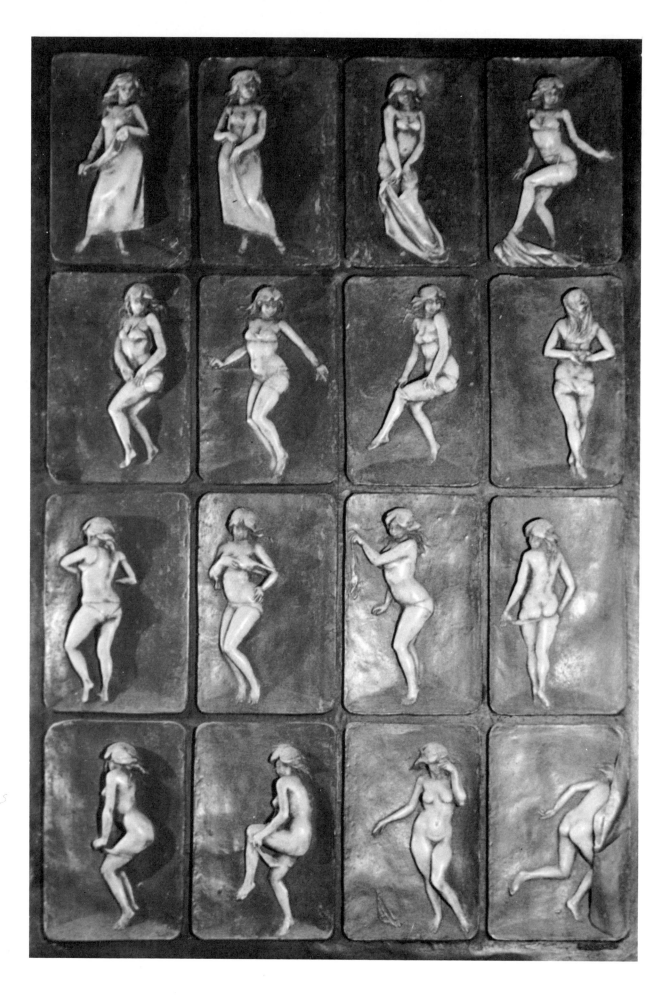

STRIPTEASE *(Left)*
Epoxy, 36" × 23" (91 × 58 cm).
Private collection
Photo Malmstrom

LEDA AND THE SWAN
Terracotta, 21" × 17" (53 × 43 cm)
Photo Malmstrom

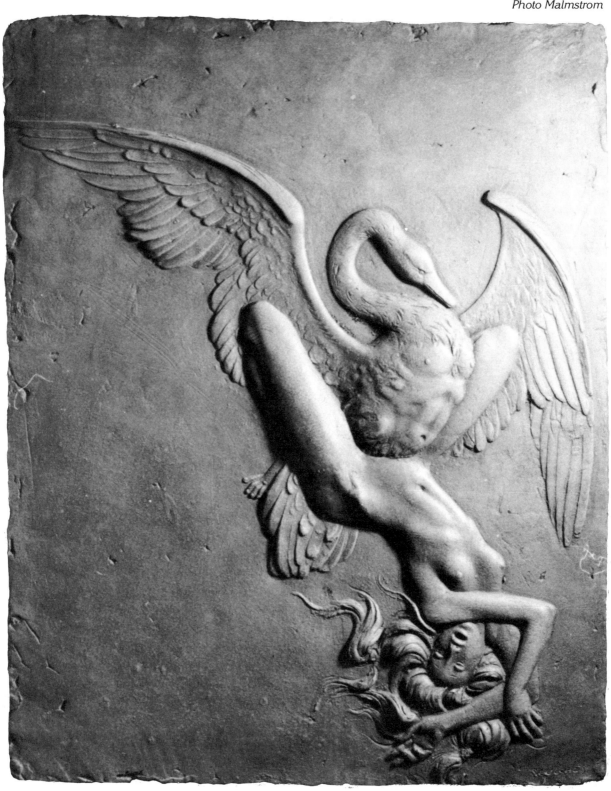

18

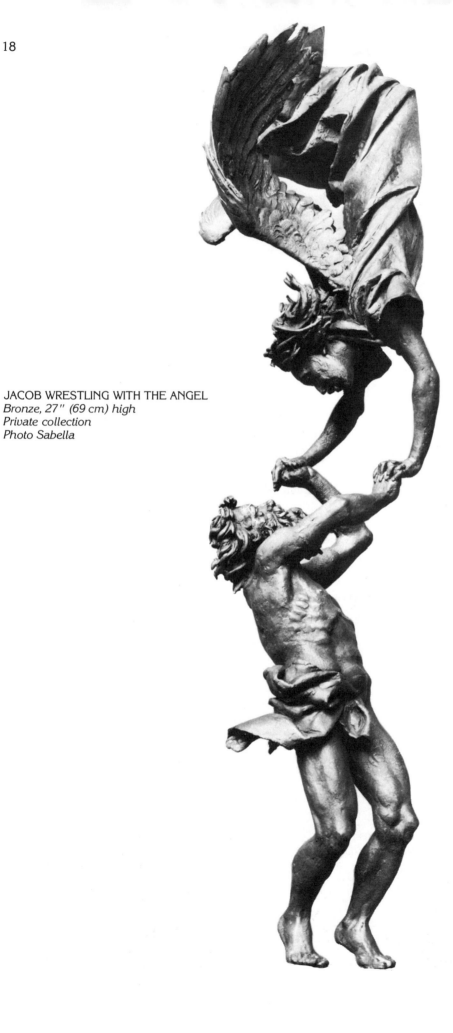

JACOB WRESTLING WITH THE ANGEL
Bronze, 27" (69 cm) high
Private collection
Photo Sabella

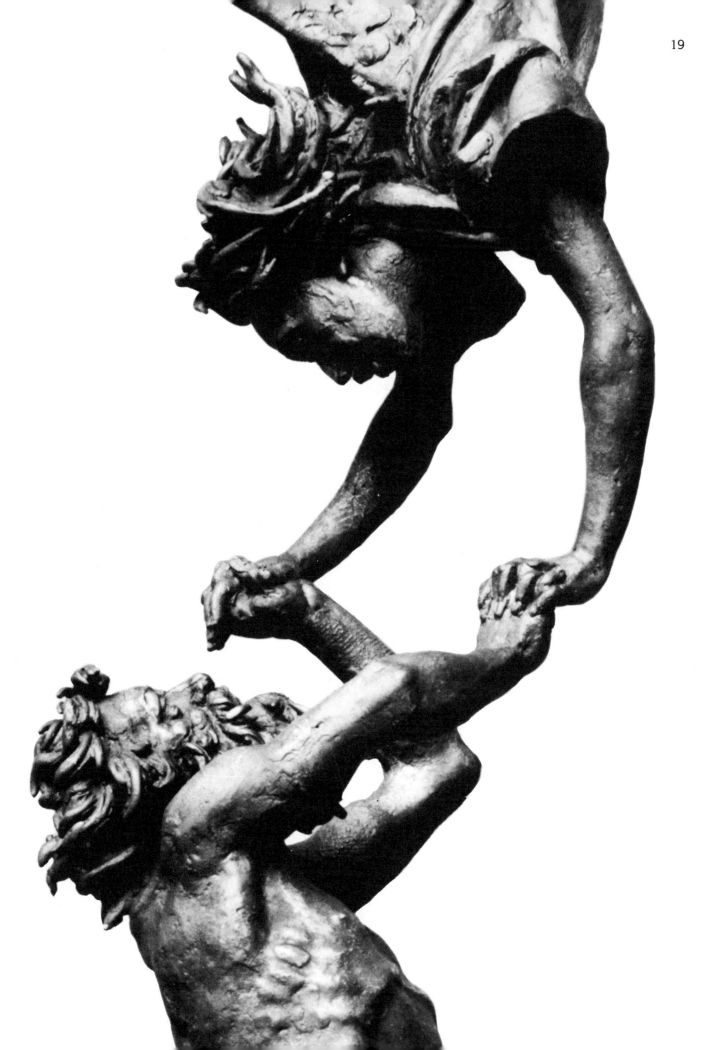

PENSIVE NUDE
Terracotta, 16" (41 cm) high
Photo Malmstrom

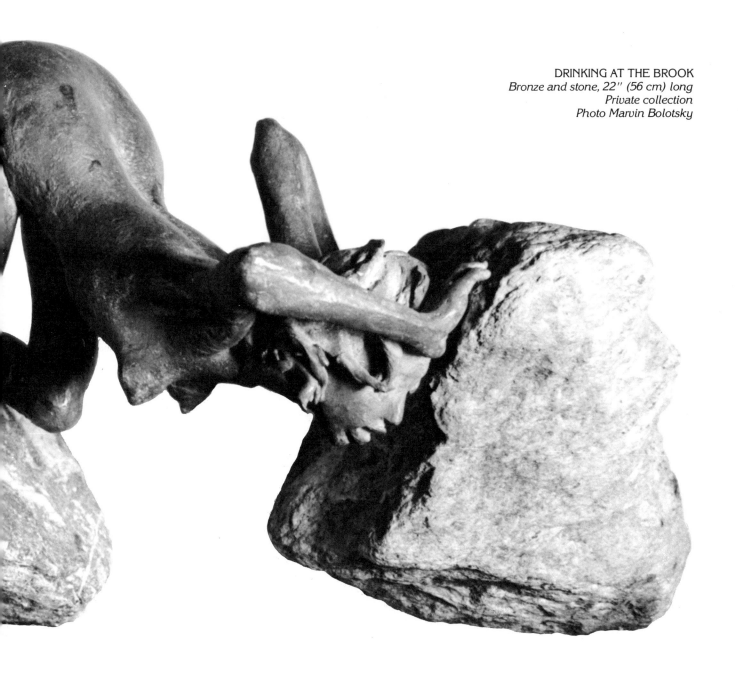

DRINKING AT THE BROOK
Bronze and stone, 22" (56 cm) long
Private collection
Photo Marvin Bolotsky

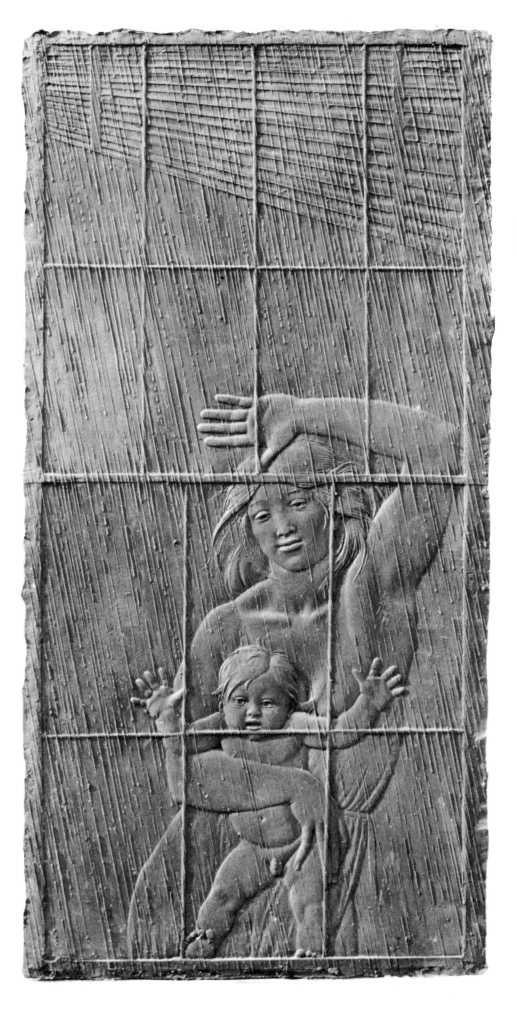

RAINY DAY
Bonded bronze
63″ × 32″ (160 × 81 cm)
Photo Malmstrom

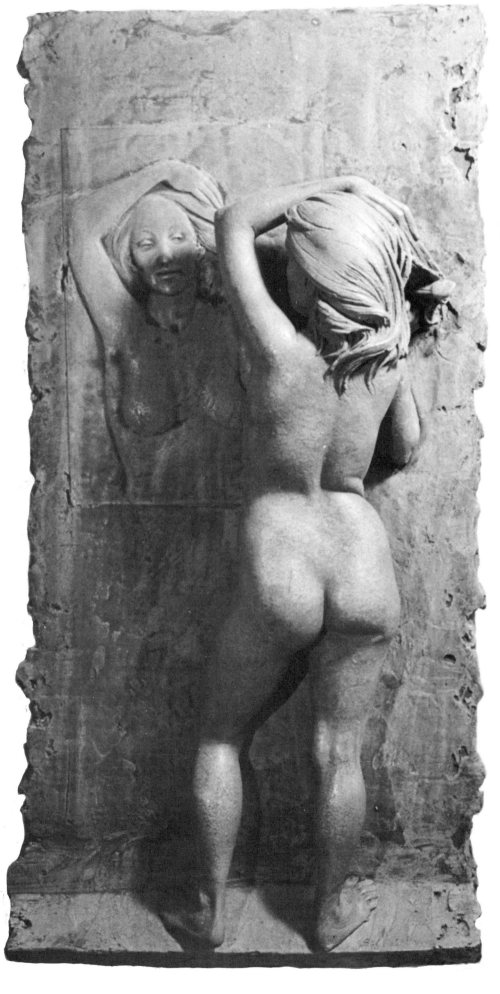

NUDE AT THE MIRROR
Terracotta
30" × 15" (76 × 38 cm)
Photo Malmstrom

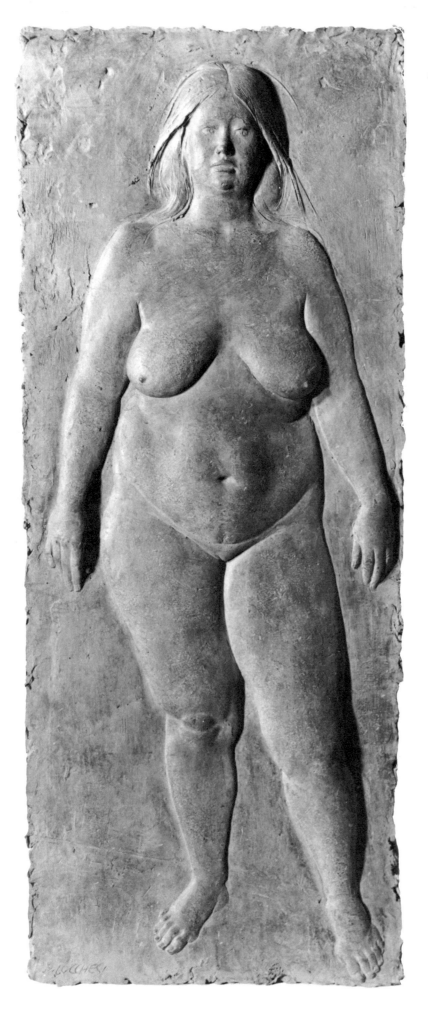

PADDY
Terracotta, 46″ × 19″ (117 × 48 cm)
Photo Marvin Bolotsky

NUDE ON CUSHIONS
Bronze, 20" (51 cm) long
Private collection
Photo Sabella

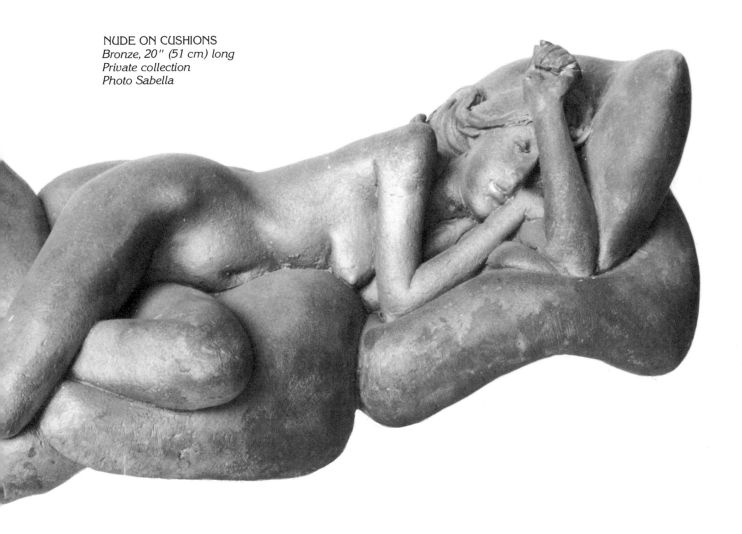

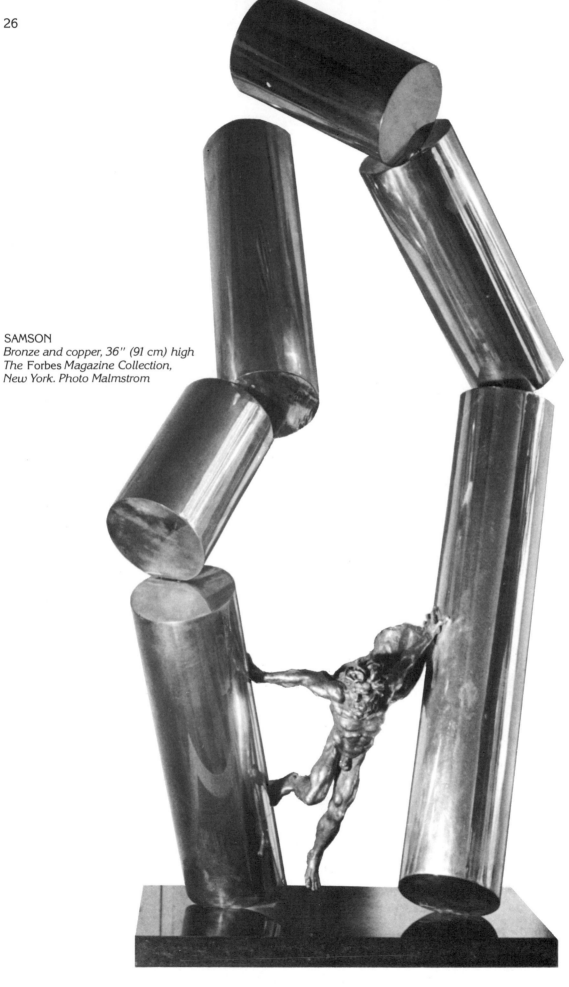

SAMSON
Bronze and copper, 36" (91 cm) high
The Forbes *Magazine Collection,*
New York. Photo Malmstrom

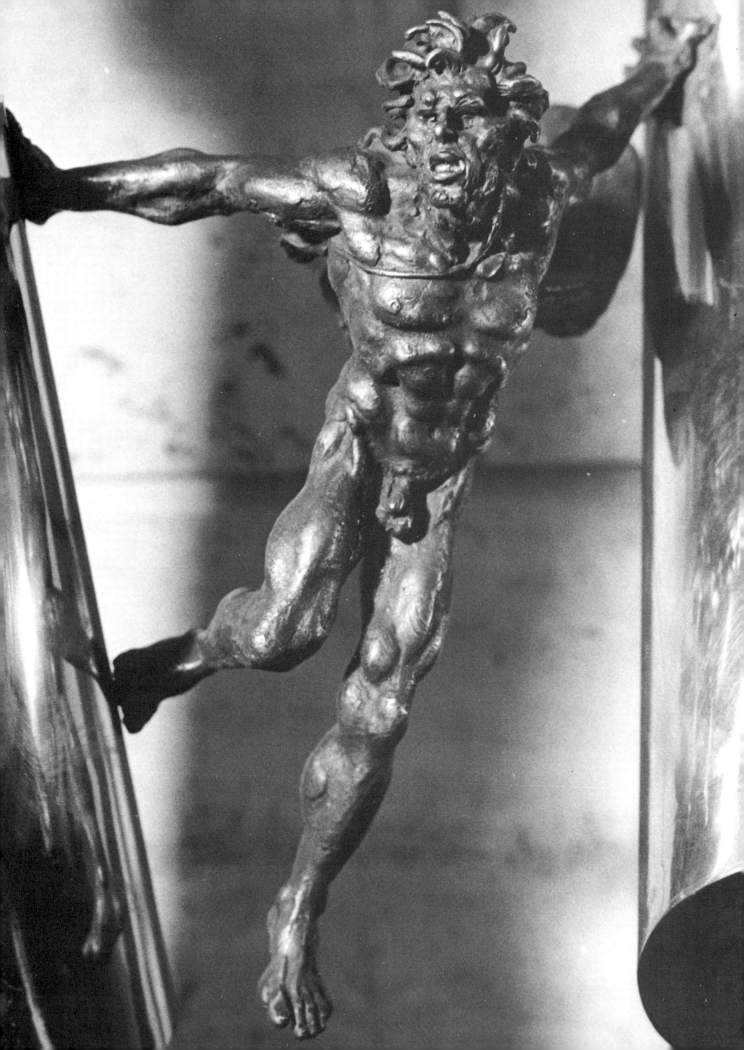

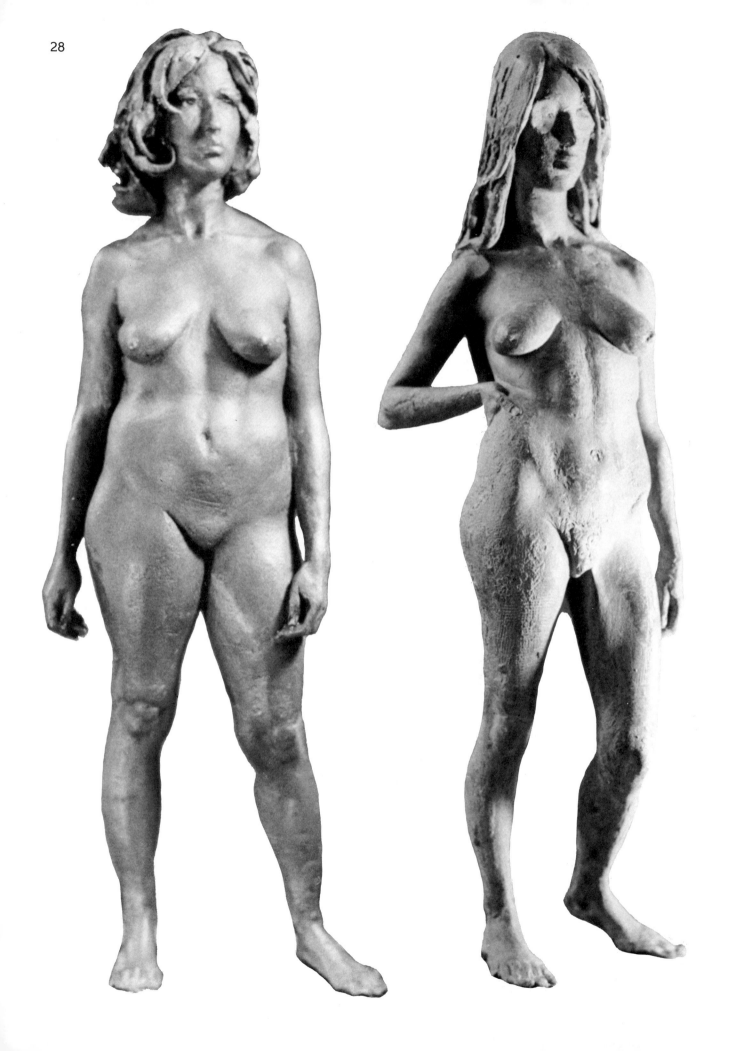

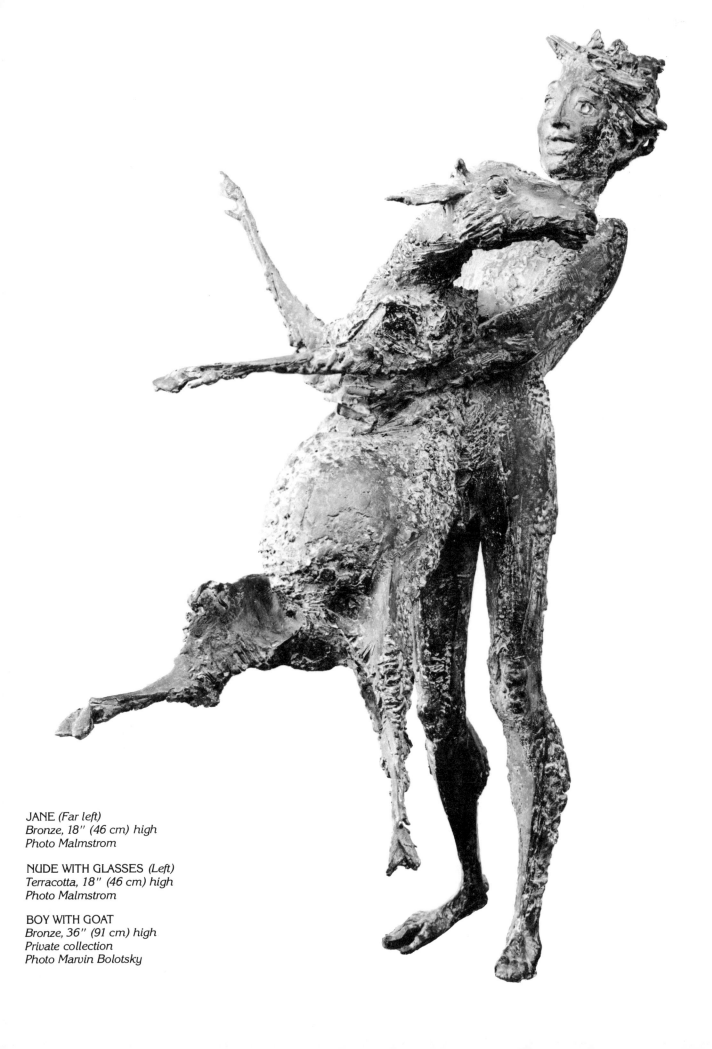

JANE *(Far left)*
Bronze, 18" (46 cm) high
Photo Malmstrom

NUDE WITH GLASSES *(Left)*
Terracotta, 18" (46 cm) high
Photo Malmstrom

BOY WITH GOAT
Bronze, 36" (91 cm) high
Private collection
Photo Marvin Bolotsky

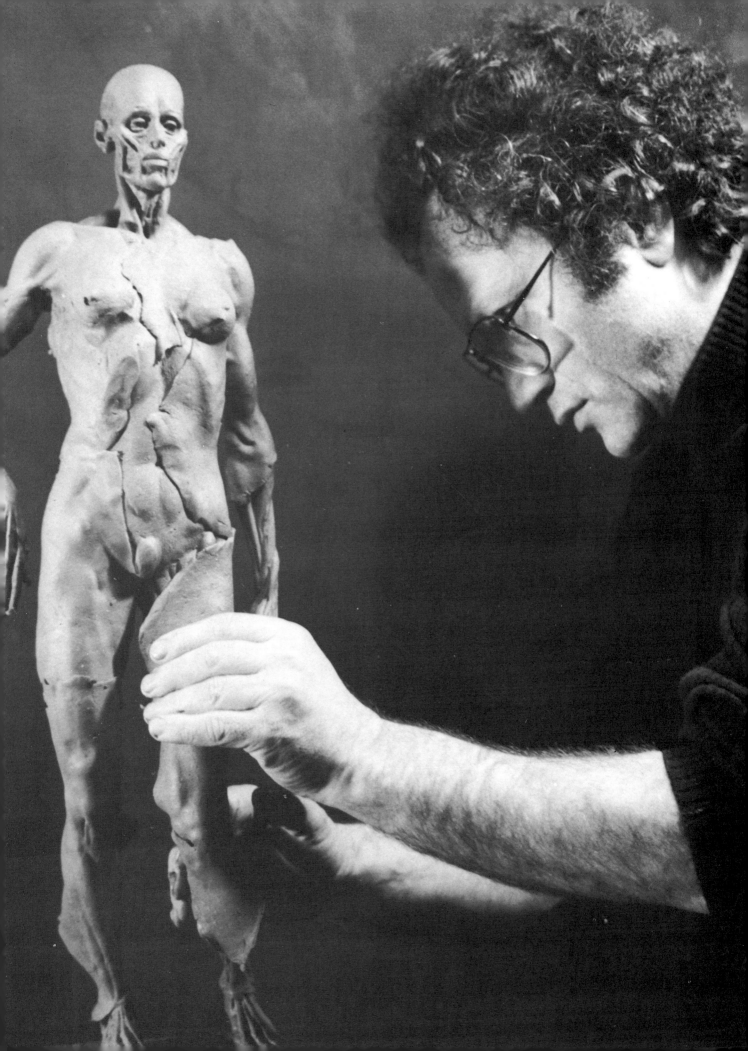

This book is meant for a special group of people who think, see, and understand form best in the round; namely, sculptors. As a sculptor myself, I have long felt the need for a reference source for human anatomy that speaks my language, the language of sculpture rather than that of drawing, painting, or photography. I thought, if only I could actually *see* how one bone attaches to the next, how a particular muscle is formed and laid on, I would be able to at least begin to understand the structure of the human body.

So, for me, this book is a dream come true. For the first time, I can actually see a body put together in sculptural terms, from start to finish. And not only *a* body, but *any* body! The figure that will evolve over the pages of this book goes through several distinct stages: skeleton; half-skeleton, half-muscled figure; fully muscled anatomical figure; a specifically female anatomical figure; and a completed female figure with skin and hair. The reader may come into this process of evolution and metamorphosis at any time, for any kind of specific reference: at the skeleton to see how the pelvis is constructed, for example, or at the anatomical figure to study the muscles of the thigh, or at the female figure to see what part of female anatomy is muscle and what part fatty deposit.

But there is more here than the facts of human anatomy. The great difference between this book and other, conventional, anatomy books is that this book shows the sculpting *process* as well as the finished anatomical references. Not only, will the reader learn where each bone and muscle goes, but *how it is*

made; that is, how it is modeled in clay! In this way the reader not only comes into contact with the facts, but more important, learns how to use these facts to build up a figure, male or female, in clay.

To make both the facts and the process of building up the figure as clear as possible, Bruno Lucchesi has modeled each bone and muscle carefully. Of course he does not actually work this way when he makes his sculptures; such painstaking detail would be both unnecessary and time-consuming. But this brings up yet another way in which this book may be used: the reader may follow along and duplicate the process shown, building up a skeleton and/or an anatomical figure. This can be a valuable learning experience for those with the patience and seriousness of purpose to undertake it.

There are two ways for a figurative sculptor to work: from a model or without a model, from the imagination. Either way a knowledge of anatomy is essential. Without a knowledge of anatomy, the body remains forever a locked door. You can look at a model for years and still not understand what is going on beneath the skin to cause this bulge or that hollow. In the same way, anatomy forms the basic vocabulary of the imaginative sculptor. Without it there can be only feeling, but feeling without form is rarely, if ever, communicated to anyone else. So think of this book as your A-B-Cs of human form, the beginning from which all else follows. We hope that you'll enjoy using this book as much as we enjoyed creating it!

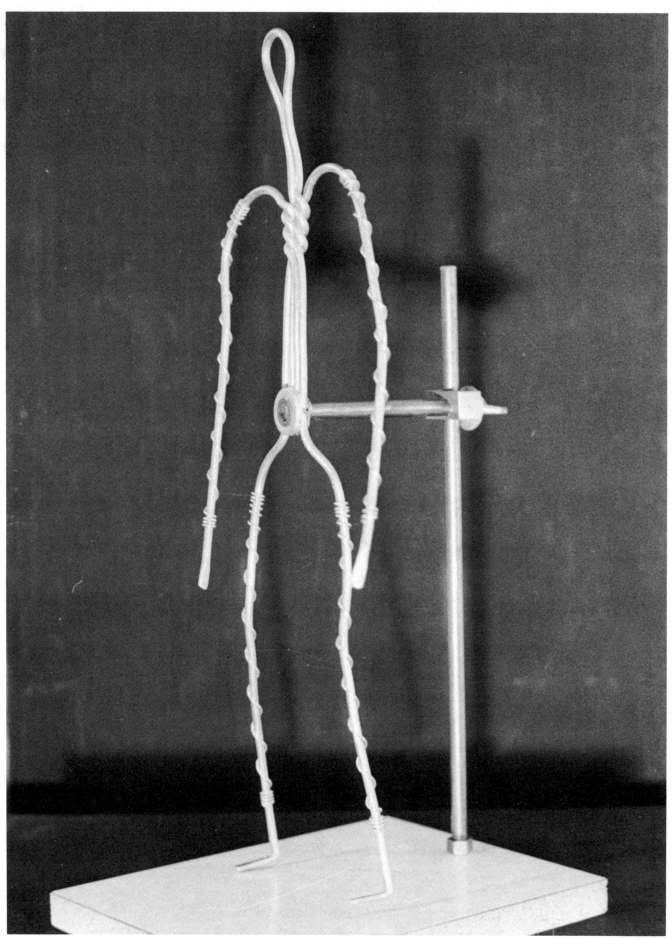

This armature is 18" high and has an adjustable back iron that allows it to be raised or lowered to a sitting or reclining position.

To begin with, let's look at the tools and materials needed to model a figure in clay. We'll show you a cross-section of Lucchesi's favorite modeling tools; although you may not see him working with all of them in this book, these are his constant companions in the studio and represent the kinds of tools you're likely to require. (Sculpture suppliers as well as casting and firing services may be found under "Suppliers" at the back of this book.)

ARMATURE

When building up a figure from the inside out, the first thing you need is an armature, or support of some kind, on which to fasten the clay. Lucchesi often makes his own armatures, and in this case he constructs a figure armature out of a length of aluminum wire nailed to a wooden base. His figure armature is very similar to commercially available ones, except that it doesn't have a rigid upright in the center, which means that it is less stable than it could be.

The figure armatures available from art supply stores are made from wrapped aluminum wire held by a back iron, and can be either adjustable (allowing the figure to be moved up and down) or non-adjustable. The base is usually covered with Formica.

A word of caution about armatures: don't fire a sculpture that is built on an armature unless you know what you're doing! Lucchesi did in fact fire this piece with the aluminum armature still inside (with the wooden base removed, of course). The heat from the kiln simply melted the aluminum and it ran out the soles of the feet. But what you don't see is that before firing, the clay cracked as it dried on the armature. This always happens when you leave a non-yielding object inside the drying, contracting clay. So unless you're adept at repairing cracked and broken sculpture, it's not advisable to fire a piece with the armature inside.

CLAY

Next, you need clay to cover the armature. Lucchesi uses a red water-based modeling clay with no grog. Modeling clay is available from sculpture suppliers in a variety of colors, from grays and reds to white and black. Each color and kind of clay has its own particular characteristics in terms of handling and firing, and the only way to know if you'll like working with a certain clay is to try it. All modeling clays can be fired in a kiln and all can be used for making molds. So the clay you buy will

depend on the color and plastic properties you like, as well as on the price.

Modeling clays may be purchased dry, in which case you have to add water, or moist, ready to use. They come in quantities ranging from five to fifty pounds. Clay will dry out if moisture is not replaced from time to time, so re-wet your sculpture-in-progress when necessary, and be sure to cover it securely between work sessions.

A dried-out sculpture is very fragile and should not be considered a finished piece. It should either be fired or be cast into some other, more durable material such as plaster, polyester resin, or bronze. Sculpture in this dried state may, however, be stored indefinitely with no harm, to be fired or cast in the future.

TOOLS

To work the clay, you need tools. Lucchesi uses *wooden modeling tools*, *wire-end modeling tools*, *plaster tools*, *flexible steel palettes*, *brushes* of all sizes and types, and an assortment of pieces of *cloth*, *wire screening*, and bits of *wood*. Tools for modeling clay are available in an enormous range of shapes and sizes, and the only way to find out which ones will suit you is to try out a variety. You'll need different tools to accomplish different tasks: the modeling tools are used as extensions of your hand, for modeling and laying on clay; the wire-end tools are for shaving off, cutting away, and gouging out clay; the steel tools, because they are flexible and sharp, are good for smoothing and pulling together the surface, for cutting away, and for making sharp lines and clean accents in the clay; the brushes and rags are used either wet or dry to blend the clay surface into a smooth texture as well as, with pressure, to model forms. Lucchesi uses bits of wire screen to gouge out large areas of clay and to shave clay off the surface.

Preferably, you should have a few of each type of tool, as well as any pieces of wood, doweling, or odds and ends you have around. You'll find, as your work, that almost anything can be used as a modeling tool!

MODELING STAND

Ideally, you should have a floor-standing modeling stand to work on. Stands are available in a wide range of prices, the sturdier ones being more expensive, but even the least expensive stand is fine for modeling small to moderately large clay sculptures. Some stands are mounted on casters so you can roll them around, and all have

A 25-lb. bag of moist red modeling clay, without grog. It is ready to use just as you see it here, straight from its container.

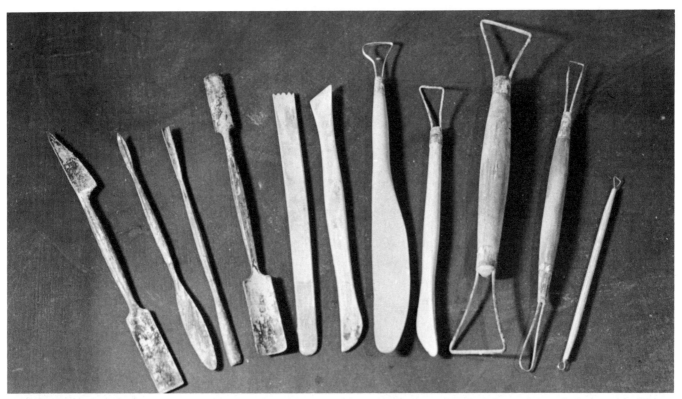

This is a full range of modeling tools that includes everything you'll be likely to need. From left to right: steel plaster tools (also called Italian plaster tools), wooden modeling tools, single-end wire modeling tools, double-end wire modeling tools, and a delicate double-end tool with an aluminum shank for fine modeling.

Any kind of brush may be used for working with clay as long as the bristles are securely anchored in the ferrule. This selection includes a housepainter's bristle brush, a watercolor brush, a small bristle brush, and a whisk broom.

These, too, are useful for modeling clay. From left to right: a rigid scraper, a flexible steel palette, two bits of wire screening, and a piece of burlap (hessian in U.K.).

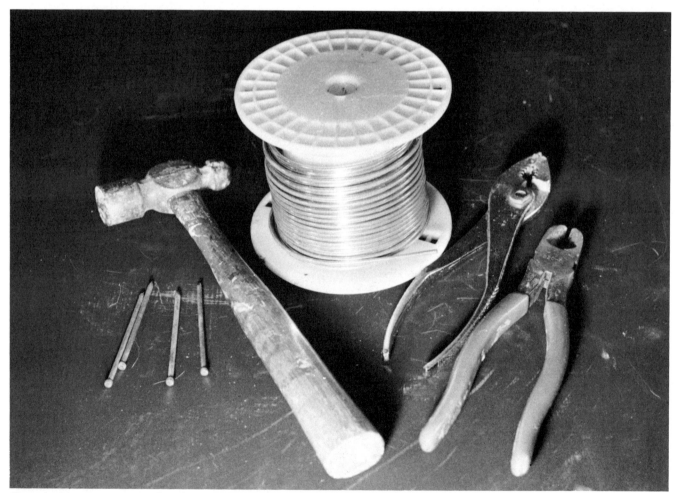

To make his own armature, Lucchesi used aluminum wire, bending it with pliers and cutting it with wire snips. He secured the armature to a wooden base by driving nails into the wood and then bending them tightly over the wire "feet."

rotating modeling surfaces that can be adjusted up or down to accommodate your desired working height.

ODDS AND ENDS

To keep the sculpture stable as you work, secure the base of the armature to the working surface of the modeling stand with some kind of clip or clamp. We recommend an ordinary hardware store *C clamp* (*G cramp* in the U.K.) for this purpose. They are available in all sizes.

To keep the clay moist between work sessions, wrap it in a damp cloth and cover it with a plastic bag. If the clay is sufficiently moist, omit the cloth and use only the plastic. If the clay gets too wet, the sculpture tends to disintegrate.

To wet the clay while you're working, a *plant mister* (plastic spray bottle used to mist plants) is ideal. They are available at hardware stores and five-and-dimes.

If you wish to dry out the clay before it happens naturally, you can play a *propane torch* over the surface. Also, a lamp closely focused on the area you wish to dry will help.

For water and slip (clay the consistency of heavy cream), you need an assortment of containers, preferably non-breakable. Plastic food storage containers work very well for this purpose.

Skeleton

First, Lucchesi will model a skeleton, bone by bone, over an armature made from aluminum wire. This skeleton is meant to be relatively sexless so that it can be used as reference for either male or female figures. There are certain differences, however, between the skeleton of a man and the skeleton of a woman: the male skeleton is usually larger than the female skeleton; a woman's pelvis is wider than a man's, and her shoulders slope more. Since we've all seen slight men with delicate bones as well as women with very narrow hips, it should be understood that these differences represent a general norm but not each individual case. Basically, we all have the same arrangement of bones whether we are male or female, and that skeletal arrangement is what we'll look at in this section.

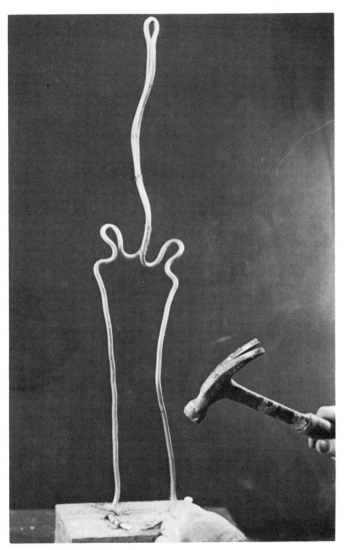

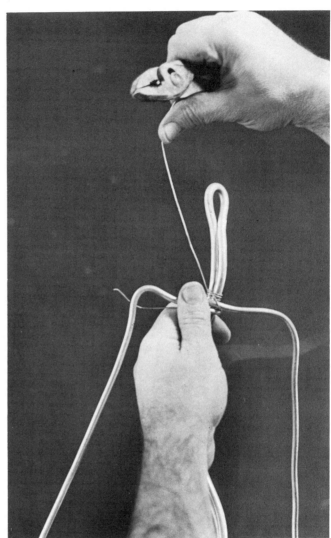

First Lucchesi makes an armature by bending a length of aluminum wire to form the head, spinal column, and legs. He nails the ends of the wire to a piece of wood, bending the nails over to secure the armature in an upright position. The two loops will support the clay forming the pelvis.

He attaches another length of aluminum wire to form the shoulders and arms, binding it in place with thinner wire and pulling it tight with a pair of pliers.

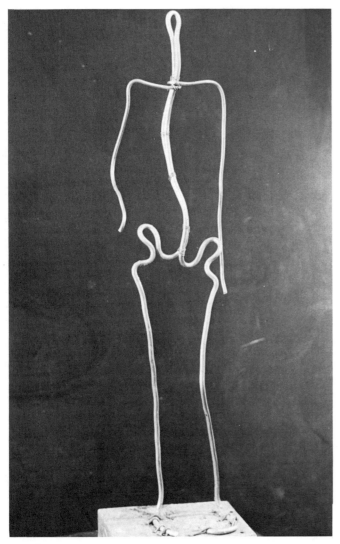

The finished armature is similar to one you could buy at a sculpture supply store. It stands 26″ high.

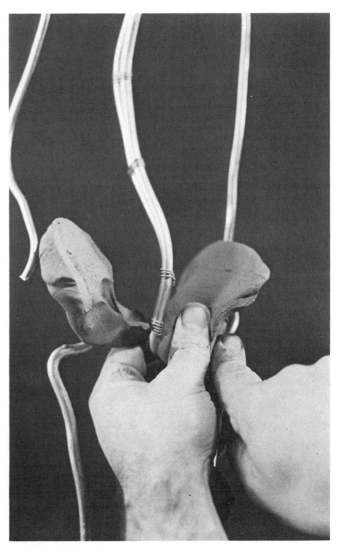

Now Lucchesi begins to add clay to his armature, starting with the winglike ilium, or top part of the hip bone. The hip bone is made up of three sections: the ilium on top, the ischium below and to the back, and the pubis in front.

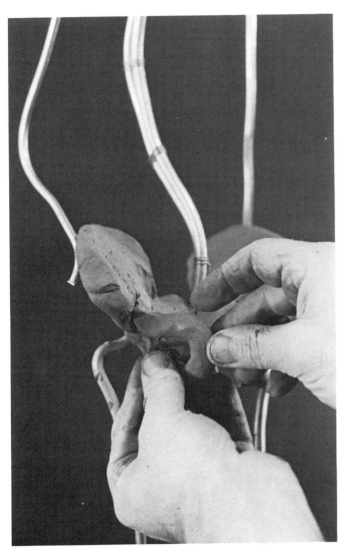

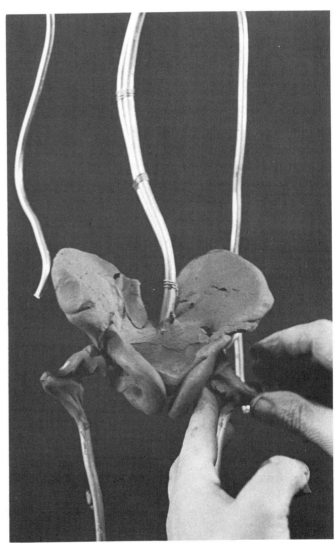

Here he adds the ischium, which loops from front to back below the ilium.

He has added clay at the front to form the pubis, or pubic bone. Now he models the head of the femur, where the upper leg attaches in a ball-and-socket joint to the hip bone, and he models the great trochanter, the most protuberant part of the leg.

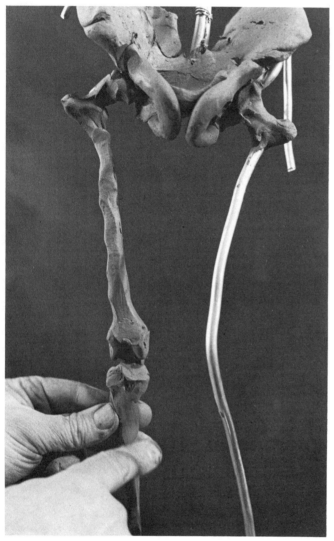

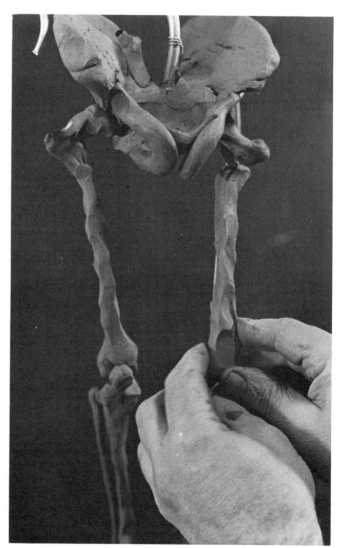

Lucchesi has pressed clay around the armature to form the femur, or thighbone, and is working on the two bones of the lower leg, attaching the head of the fibula, the smaller of the two bones, just below and in back of the tibia, or shinbone.

He has positioned the patella, or kneecap, over the end of the femur, and now adds clay to the femur of the other leg.

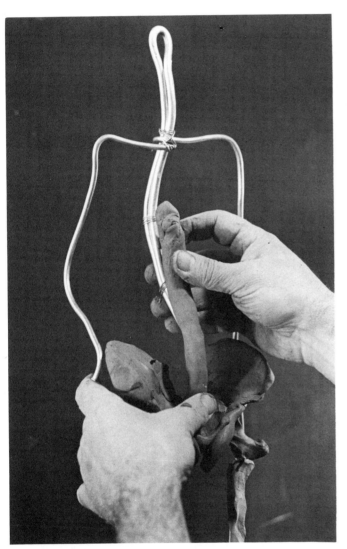

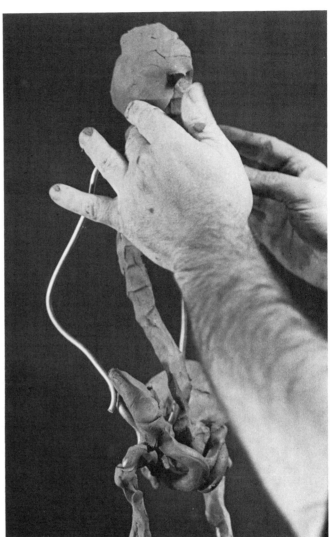

Now Lucchesi covers the spinal column with clay. There are twenty-four vertebrae in the spinal column, divided into three groups: seven cervical, which are located in the neck and serve to support the head; twelve dorsal, which the ribs attach to in back; and five lumbar, the largest of the vertebrae, which support the lower back.

He packs clay around the top of the armature to form the skull. The skull is made up of two sections: the cranium, which extends from the top of the face to the top and back of the head; and the mandible, which is the jaw.

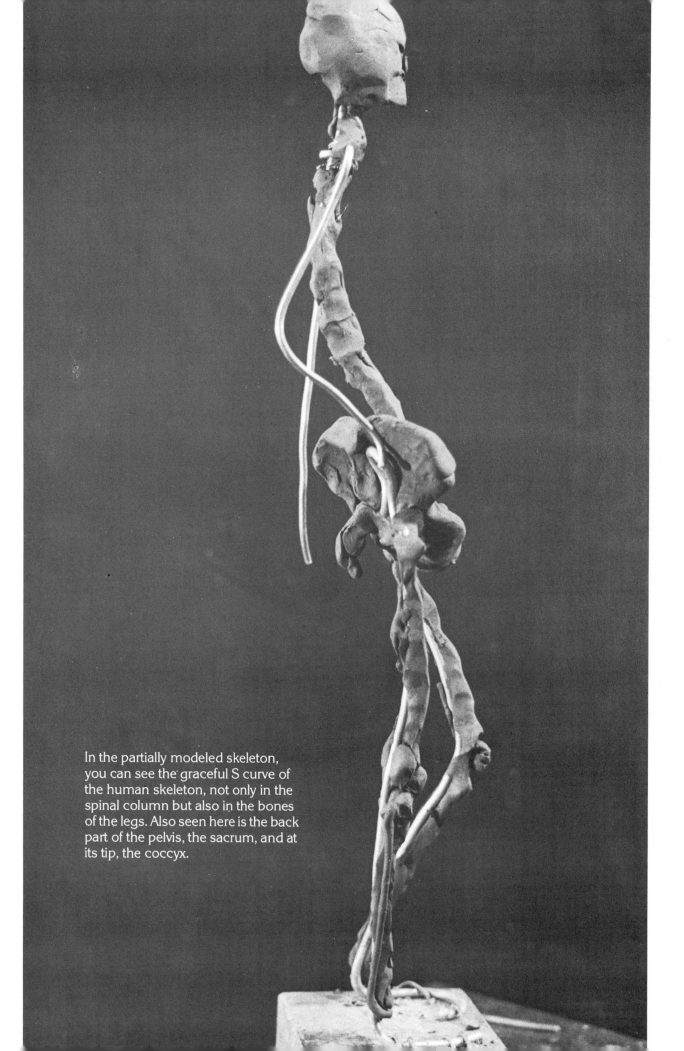

In the partially modeled skeleton, you can see the graceful S curve of the human skeleton, not only in the spinal column but also in the bones of the legs. Also seen here is the back part of the pelvis, the sacrum, and at its tip, the coccyx.

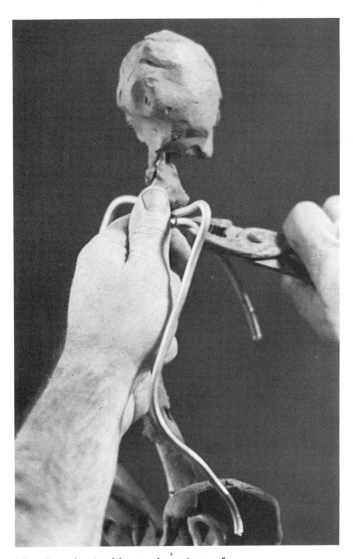

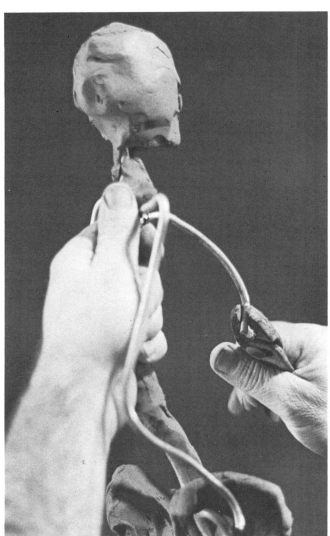

Now Lucchesi adds another piece of wire to form the sternum, or breastbone, to which he will attach the front of the rib cage.

He bends the end of the wire to achieve the roundness of the rib cage.

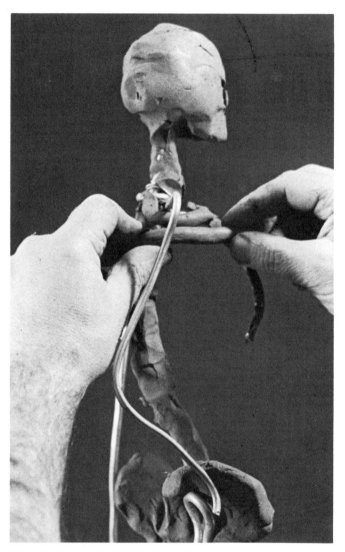

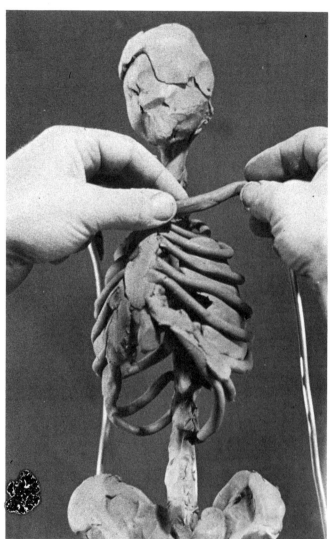

Now he lays coils of clay from the spinal column around to the sternum to form the ribs. There are twelve ribs on each side, all of which attach in back to the spinal column. In front, the first seven attach to the sternum, the next three attach by cartilage to each other, and the last two "float" with no frontal attachment.

He lays on the gently curved clavicle, or collarbone, which connects in front to the sternum and at the shoulder end to the scapula.

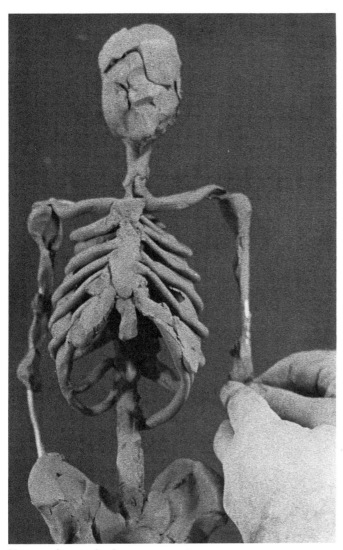

He now forms the humerus, or bone of the upper arm.

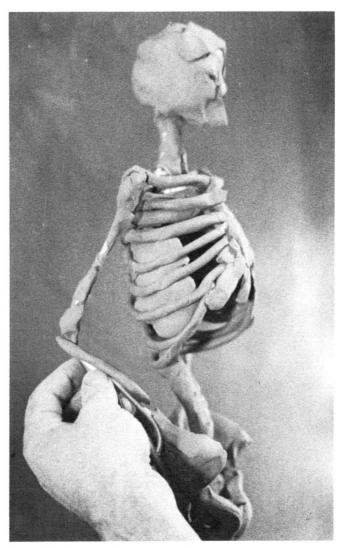

He works down to the two long bones of the forearm, crossing the radius, the exterior bone, over the armature wire which will become the ulna, the interior bone. The top end of the ulna, the olecranon, projects to become the point of the elbow.

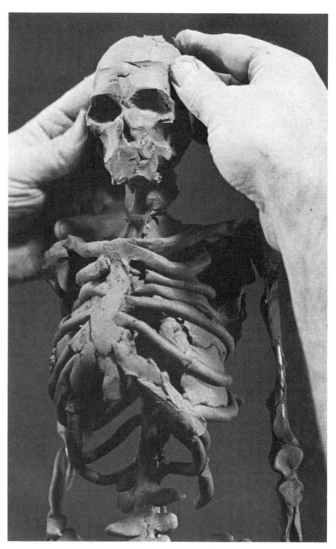

Next, he attaches the shoulder blade, or scapula, by its curved end, the acromion, to the shoulder end of the clavicle. The scapula floats freely over the rib cage and follows the movement of the arm.

He moves up to model the skull in more detail, here pressing the clay on each side of the head to form the temporal line, or indentation of the temple.

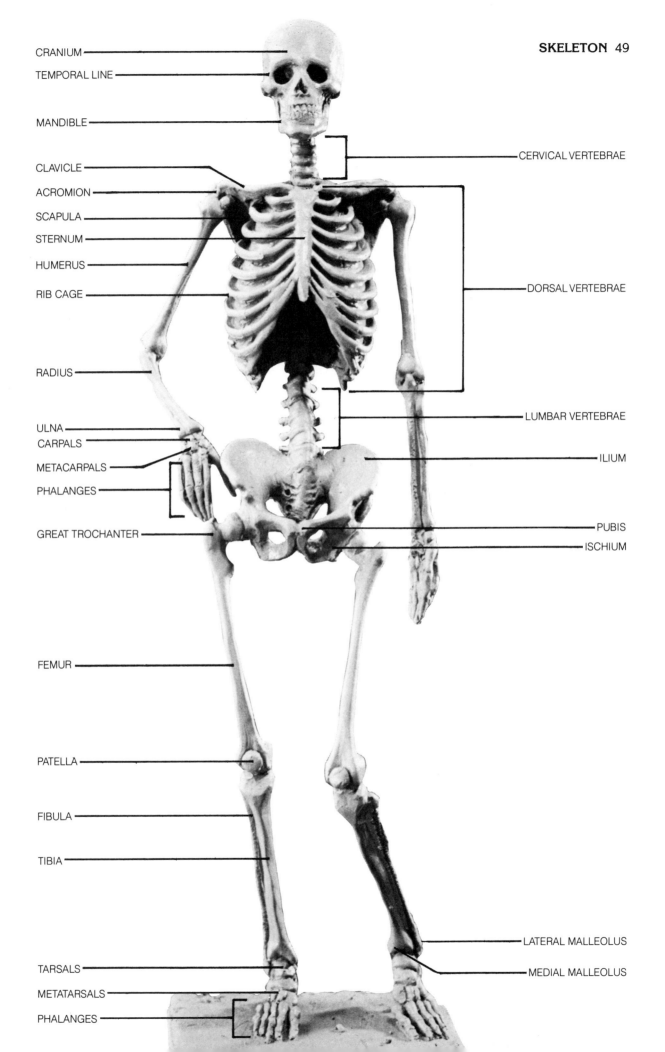

CRANIUM

TEMPORAL LINE

MANDIBLE

CERVICAL VERTEBRAE

CLAVICLE

ACROMION

SCAPULA

STERNUM

HUMERUS

RIB CAGE

DORSAL VERTEBRAE

RADIUS

LUMBAR VERTEBRAE

ULNA

CARPALS

ILIUM

METACARPALS

PHALANGES

PUBIS

GREAT TROCHANTER

ISCHIUM

FEMUR

PATELLA

FIBULA

TIBIA

LATERAL MALLEOLUS

TARSALS

MEDIAL MALLEOLUS

METATARSALS

PHALANGES

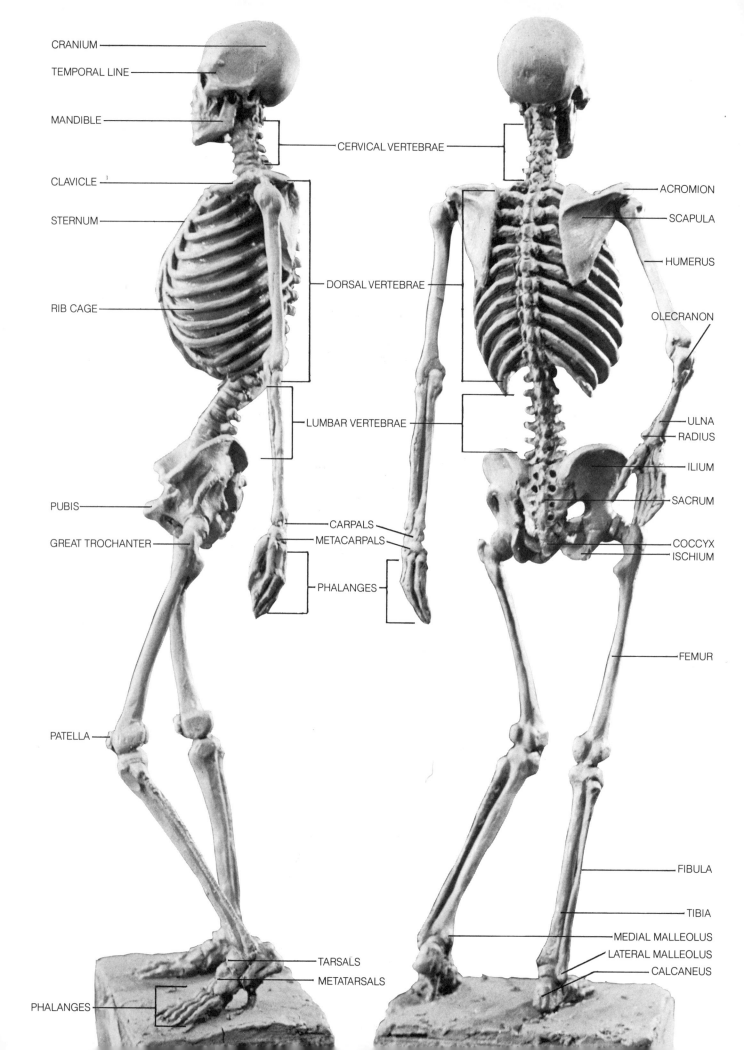

CRANIUM

TEMPORAL LINE

MANDIBLE

CLAVICLE

STERNUM

RIB CAGE

PUBIS

GREAT TROCHANTER

PATELLA

PHALANGES

CERVICAL VERTEBRAE

DORSAL VERTEBRAE

LUMBAR VERTEBRAE

CARPALS

METACARPALS

PHALANGES

TARSALS

METATARSALS

ACROMION

SCAPULA

HUMERUS

OLECRANON

ULNA

RADIUS

ILIUM

SACRUM

COCCYX

ISCHIUM

FEMUR

FIBULA

TIBIA

MEDIAL MALLEOLUS

LATERAL MALLEOLUS

CALCANEUS

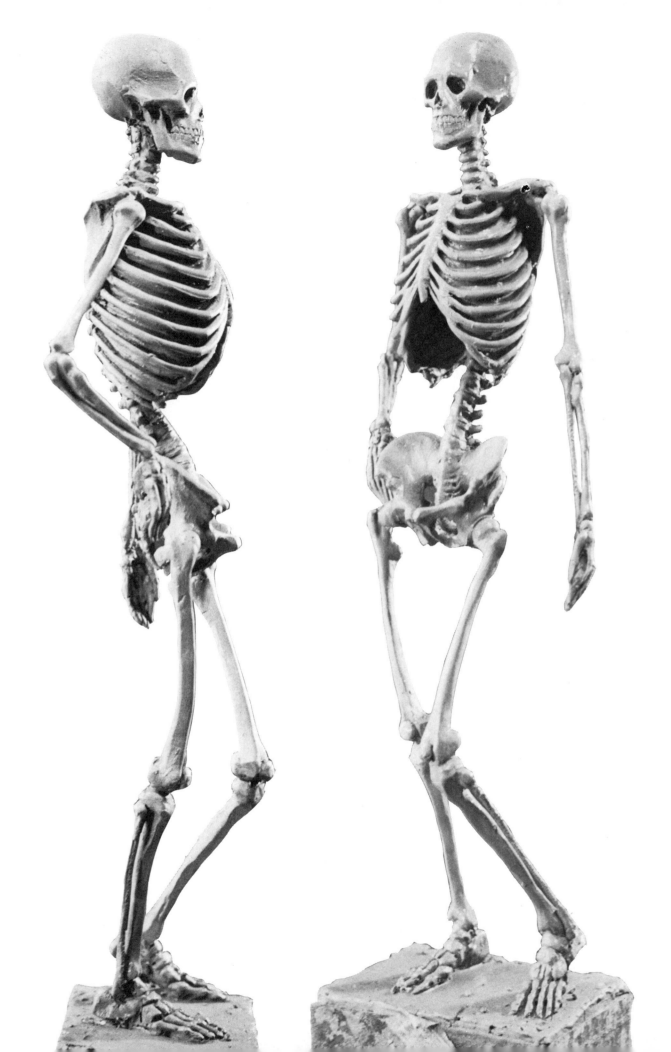

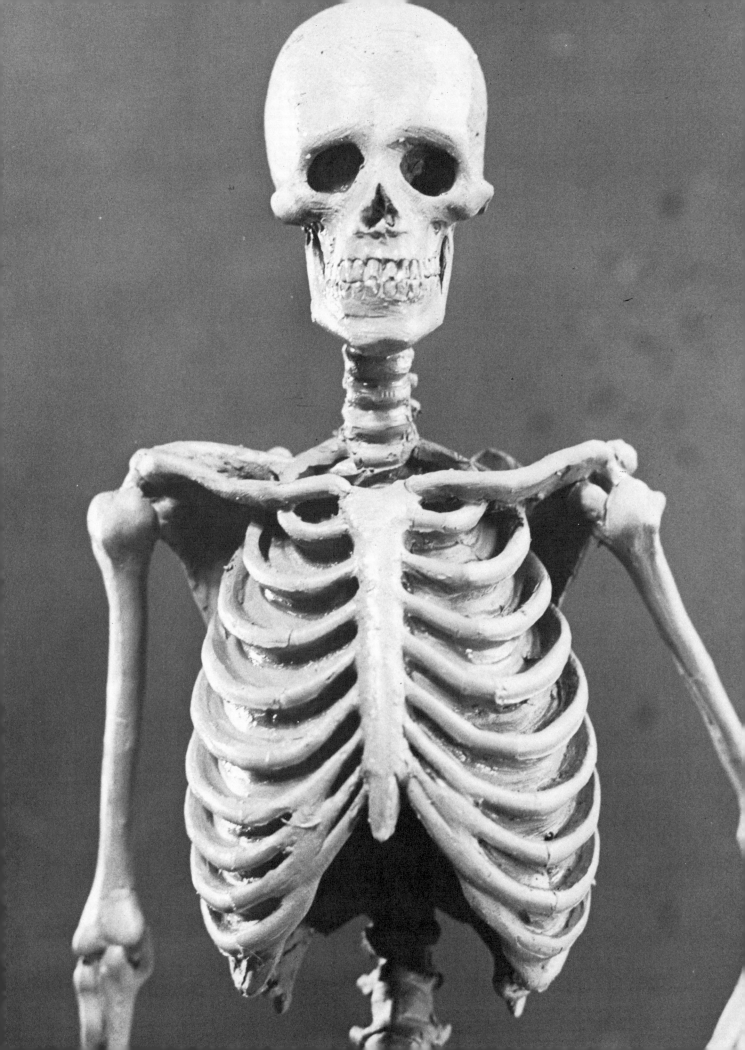

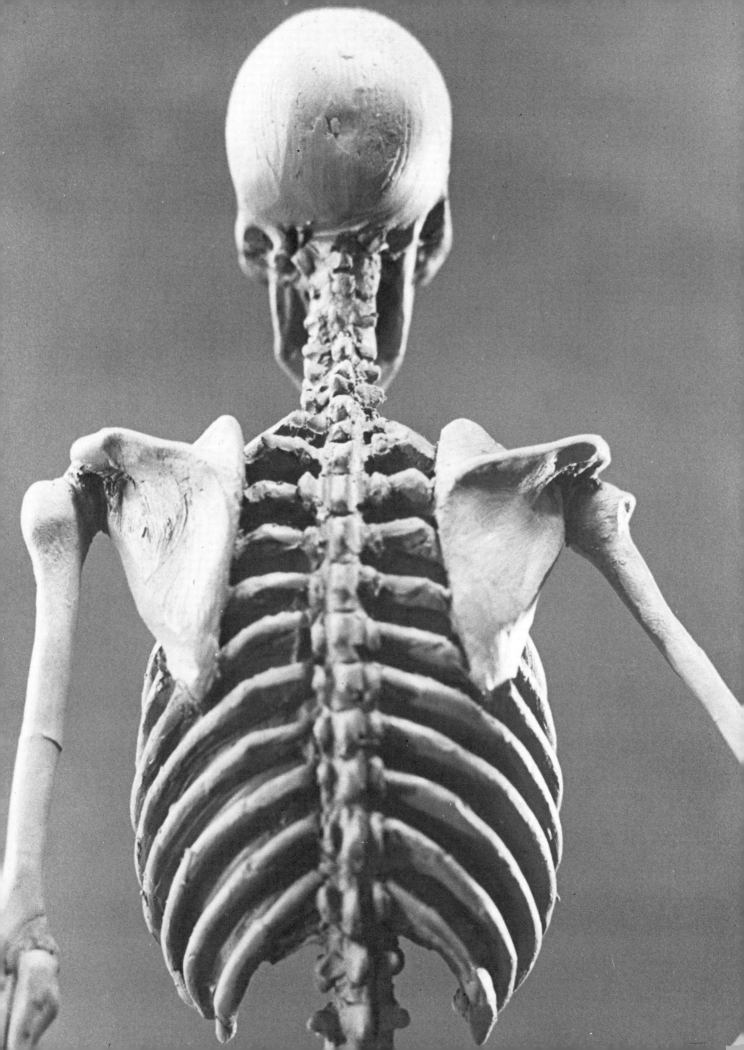

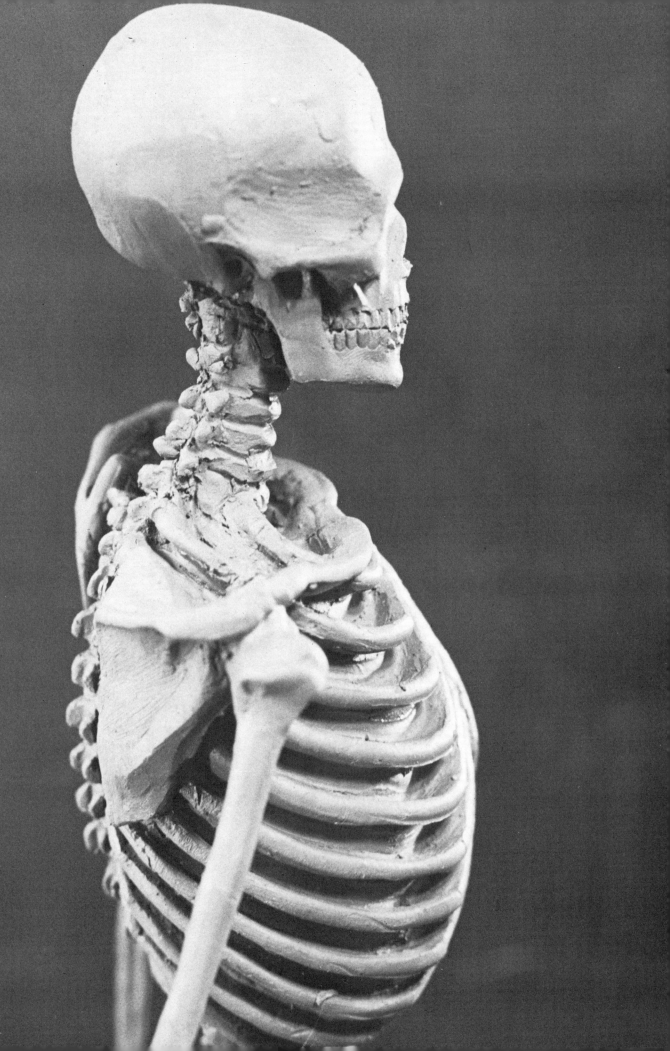

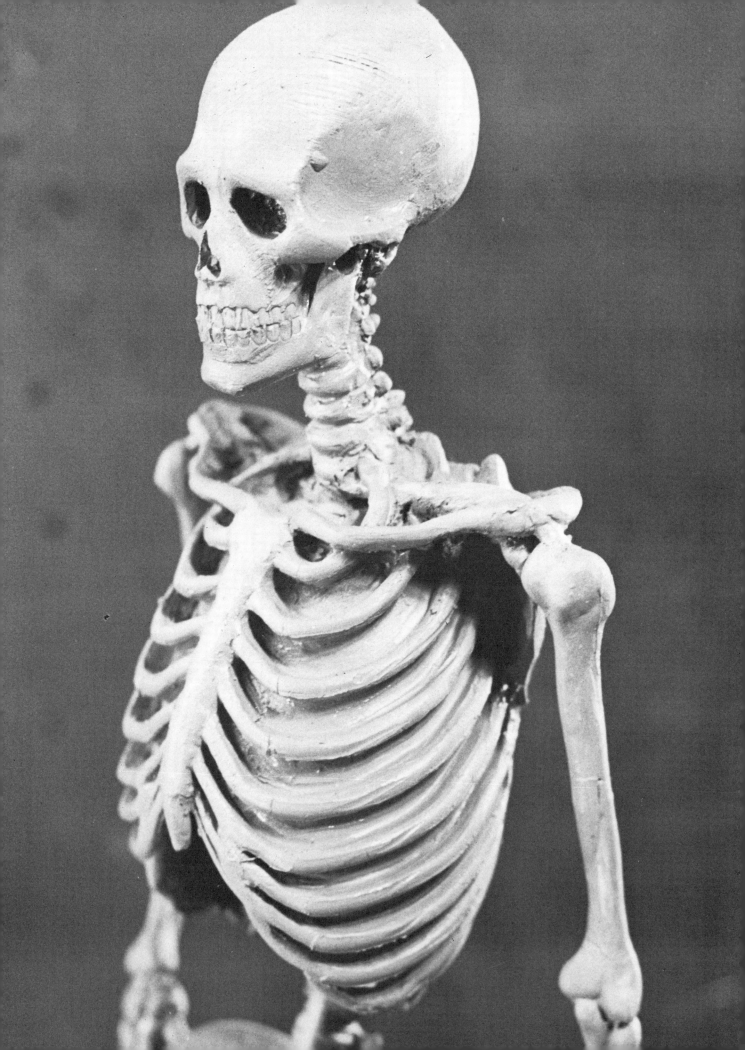

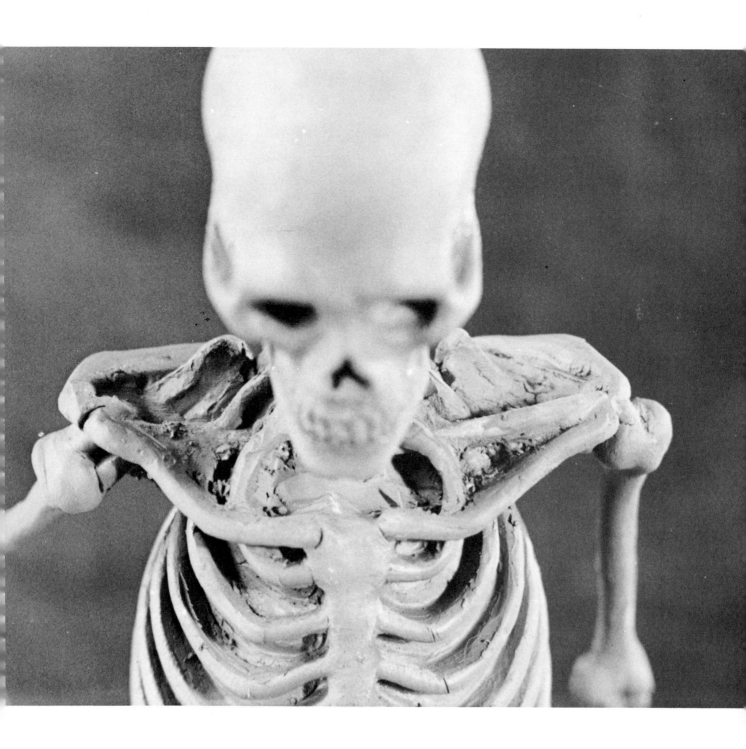

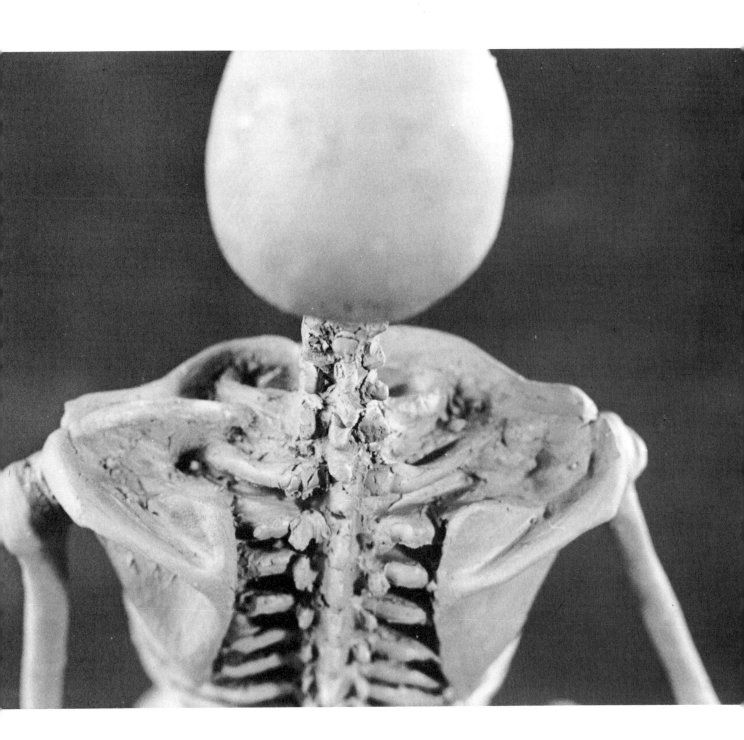

Muscles

Now Lucchesi will lay muscles over the skeleton until he has built up a classic anatomical figure. Like the skeleton, this is meant to serve as reference for both male and female figures. Again, although they tend to be more developed in the male, we all, male and female, have the same arrangement of muscles.

Some small muscles and muscle groups that you would find in a medical anatomy book are not included here because they are so far beneath the skin surface that they cannot be seen. Therefore, they have no bearing on the exterior anatomy of the figure.

In naming and labeling the muscles, we have used the original Latin so that if you wish, you can conveniently use this book in conjunction with other anatomy books, medical or artistic. We have also given the commonly used English names where such equivalents exist.

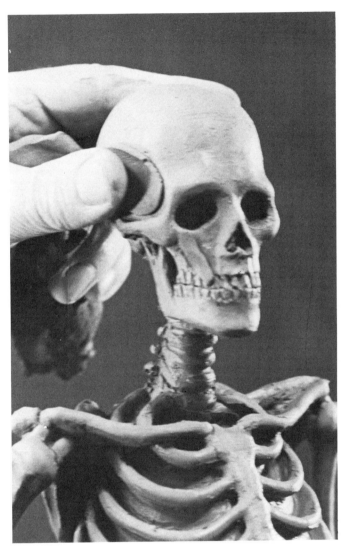

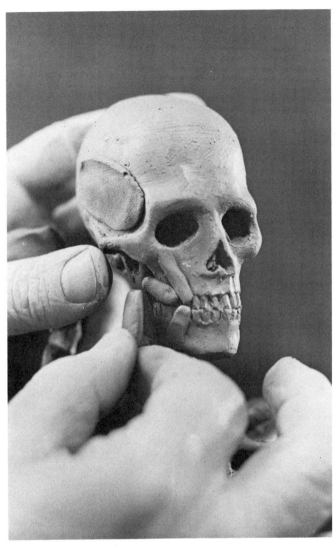

Lucchesi starts at the head, laying on
the temporalis.

He then adds the caninus and the
levator labii superioris as a single mass
of clay going upward, the depressor
labii inferioris going downward, and
the buccinator going toward the back
of the jaw.

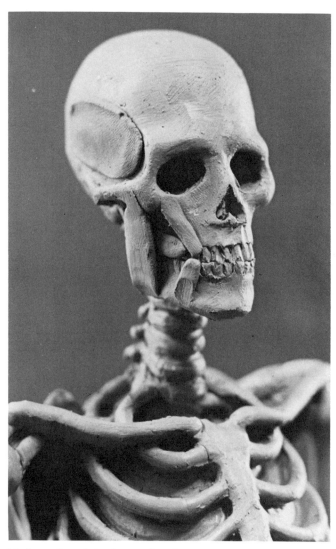

He has placed the large chewing
muscle, the masseter.

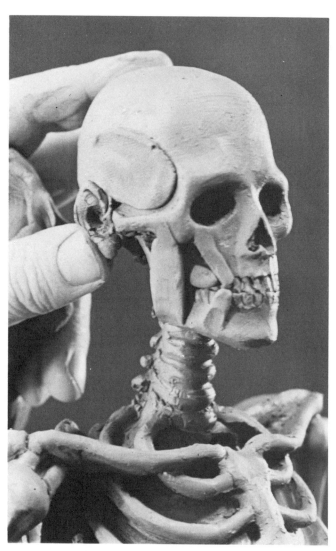

He positions the ear at the end
of the cheekbone.

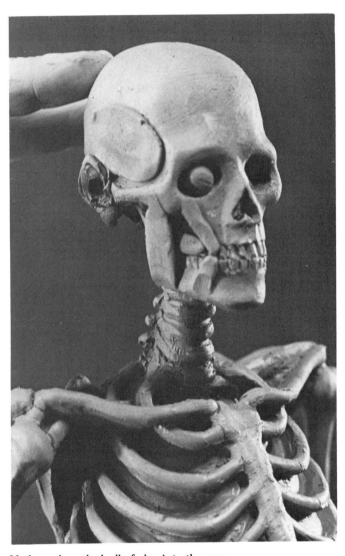

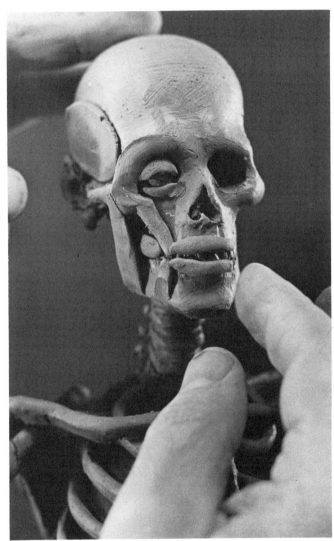

He has placed a ball of clay into the eye socket to form the eyeball. Note the angle of the ear from top to earlobe and the S shape of its curving form.

The mouth is formed by a sphincter muscle, the orbicularis oris. The eyeball, too, is surrounded by a sphincter muscle, the orbicularis oculi, that forms the eyelids and the area just above and below.

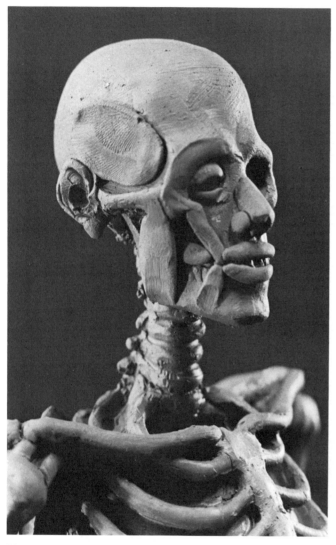

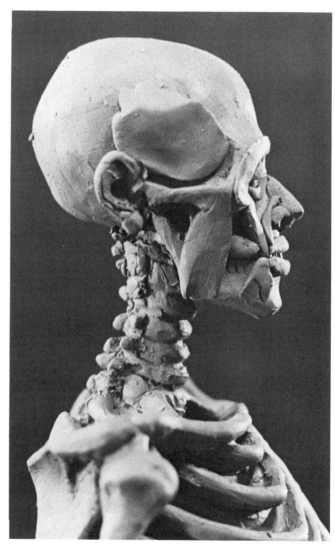

Here Lucchesi has added cartilage to the nose, as well as the dilator naris, or nostril.

He has added the levator labii superioris alaeque nasi running up the side of the nose. In this side view you can see that the ear is positioned between parallel lines running back from the eyebrow and the bottom of the nose.

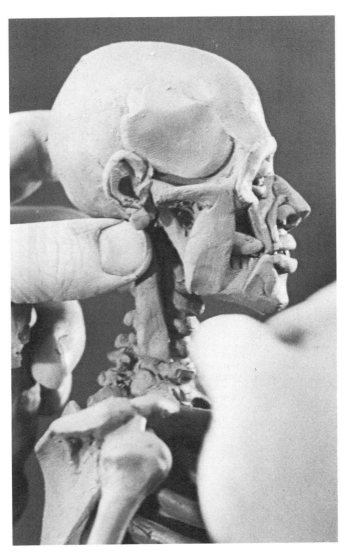

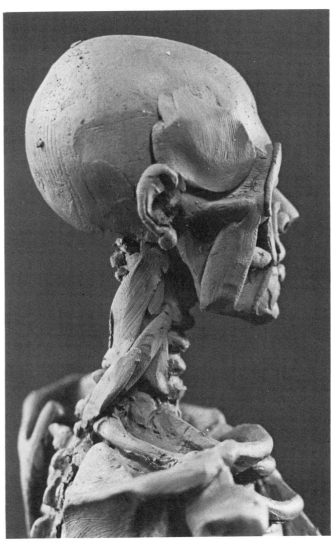

Lucchesi lays in the muscles of the neck, starting with the longus capitis.

Next he has added the two branches of scalenus posterior.

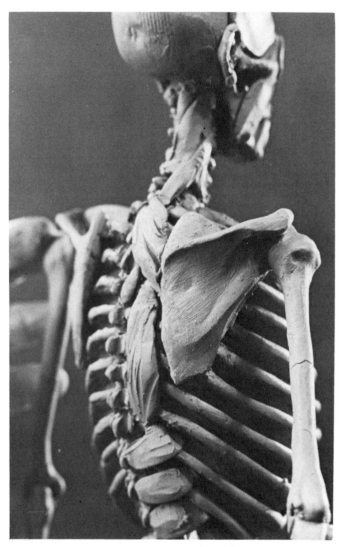

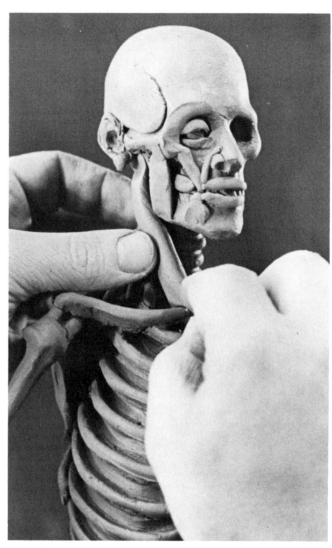

Going down along the spinal column, Lucchesi places the serratus posterior superior; the spinalis dorsi, longissimus dorsi, and iliocostalis lumborum treated as one mass; and weaving into the ribs, the serratus posterior inferior.

Lucchesi positions the major branch of sternocleidomastoideus, the most prominent muscle of the neck.

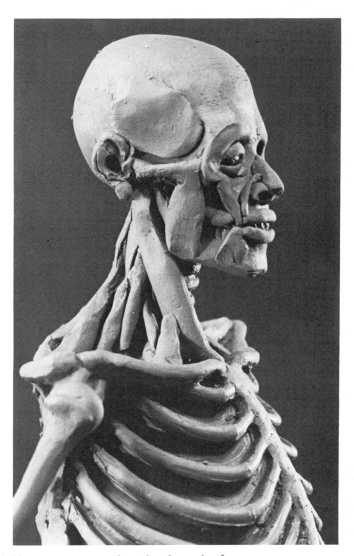

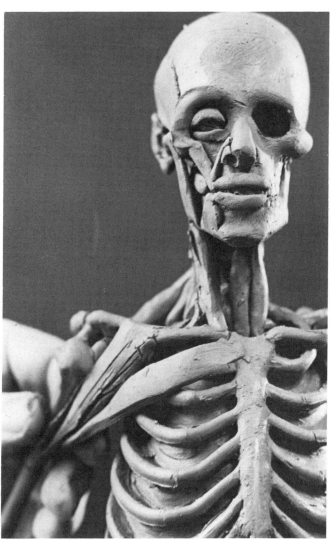

Here you can see the other branch of sternocleidomastoideus attached onto the clavicle. In the back, running from the shoulder blade up to the base of the skull, is the levator scapulae. Next to it are the two-branched scalenus posterior and the scalenus anterior.

Moving down, Lucchesi starts to lay in the pectoral muscle, pectoralis major.

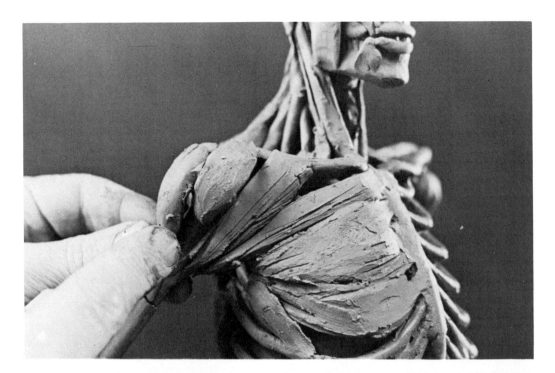

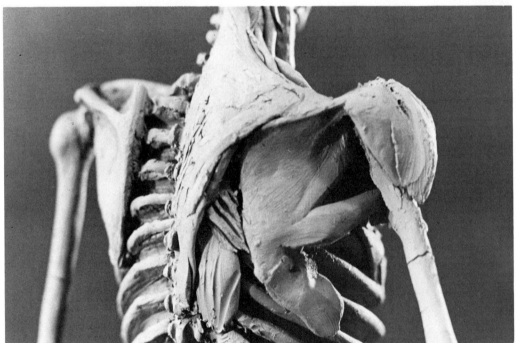

(Top) The pectoralis major is completed, and he adds the front and side branches of the three-headed deltoid muscle, the deltoideus, which forms the shoulder.

(Above) In back, he has covered the shoulder blade with the infraspinatus; branching off to attach to the arm is the teres major. Pointing downward toward the rib cage is the beginning of the serratus anterior muscles. The large muscle that fans out along the spinal column and runs up to the base of the skull and along the shoulder is the trapezius.

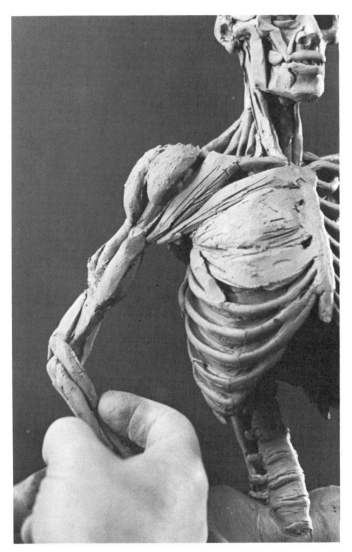

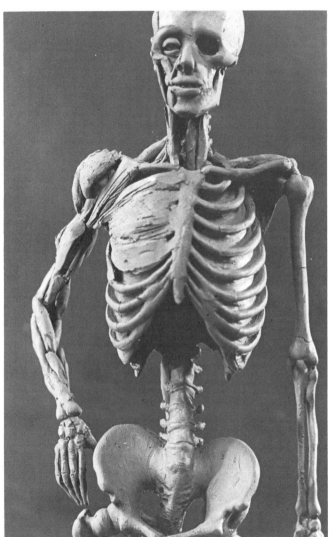

Working his way down the arm, Lucchesi adds the two-headed biceps brachii in front and the three-headed triceps brachii in back. Between the biceps and the triceps is the brachialis. In the forearm, the brachioradialis turns over the extensor carpi radialis longus.

On the inside of the elbow you can see the pronator teres, and below that, the flexor carpi radialis.

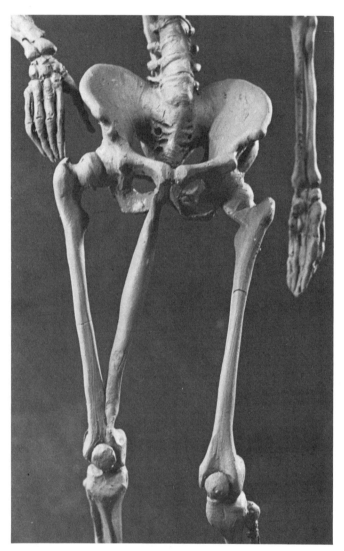

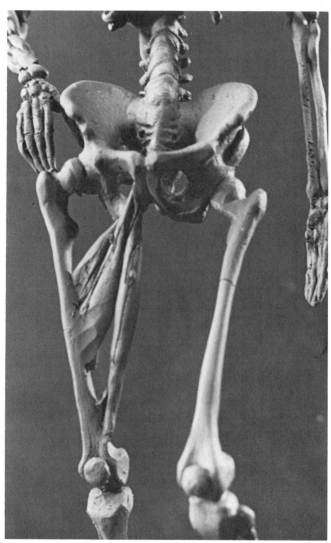

Moving down to the leg, Lucchesi has run the adductor magnus from the ischium down to the end of the femur.

He has filled in the adductor brevis and the adductor longus from the pubis to the middle of the femur.

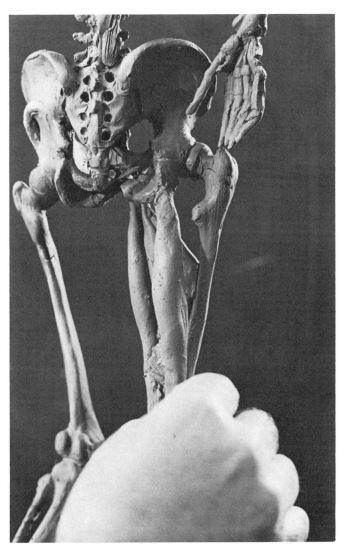

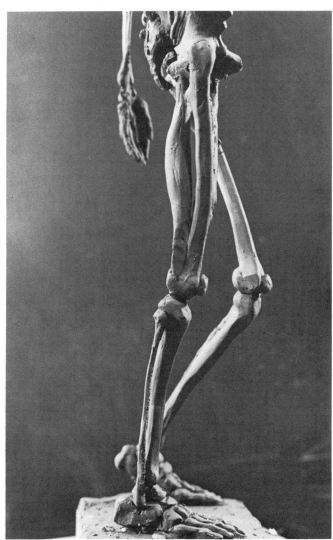

In back, running from the ischium down to the head of the fibula, is the long head of biceps femoris.

In this side view you can see how the gentle curve of the bones, together with the slightly bulging shape of the biceps, already establishes the contour of the leg.

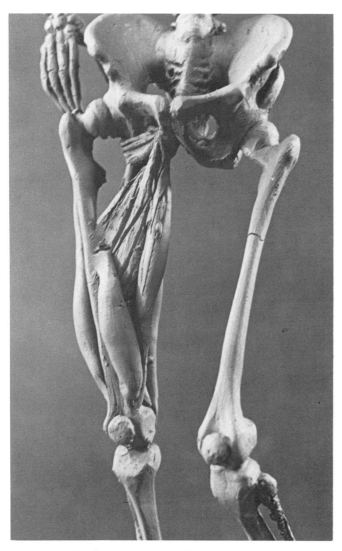

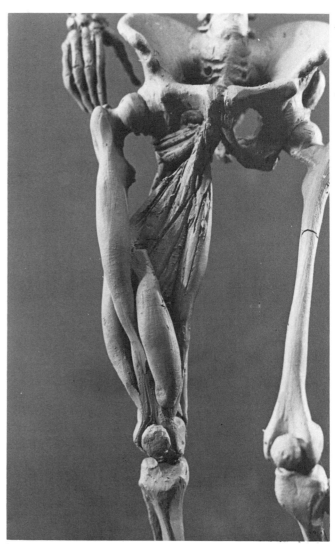

Around to the front again, Lucchesi adds the vastus lateralis, which you can see on the outside of the femur, and the vastus medialis on the inside.

Now he has laid in the large rectus femoris.

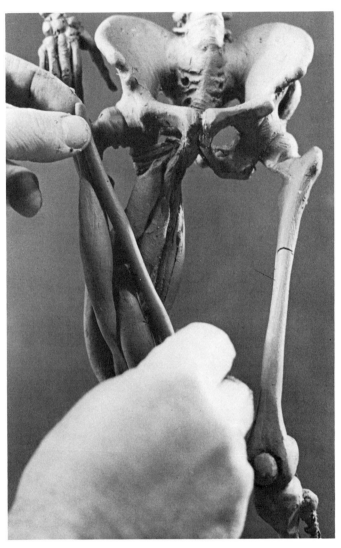

He adds the sartorius, which cuts
diagonally across the thigh.

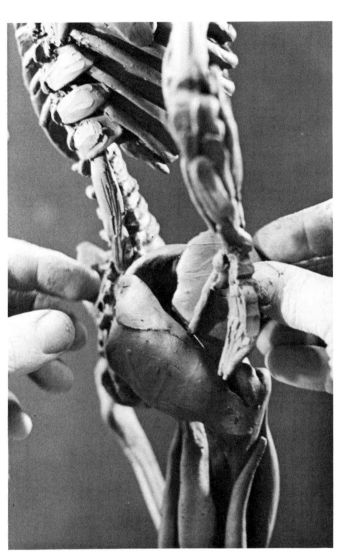

In back, he positions the two buttock
muscles, the gluteus medius above
and the gluteus maximus below.

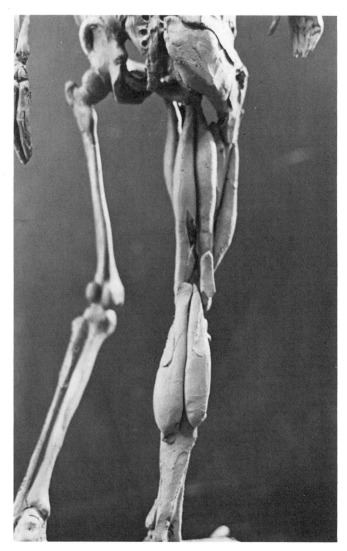

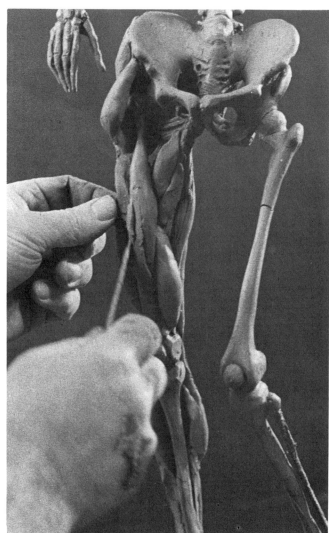

Moving down the leg, Lucchesi has added the gracilis, which you can see toward the front on the inside of the thigh. Next to the biceps femoris on the inside is the semitendinosus, and behind the knee between the two is the semimembranosus. On the lower leg you can see the two-headed gastrocnemius, or calf muscle.

In front, Lucchesi adds the tensor fasciae latae bulging out high on the hip. Below, he adjusts the vastus lateralis, rectus femoris, and vastus medialis. (The sartorius has disappeared in the modeling but will return.)

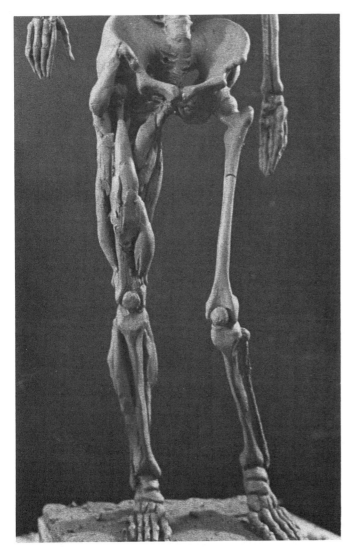

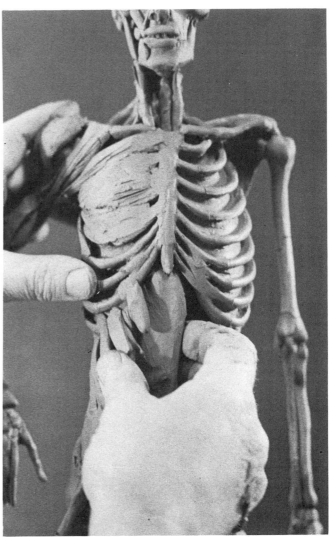

Here we pause for a moment to see how we're progressing. Notice the two heads of the calf muscle, the gastrocnemius, one visible on each side of the lower leg. In front of the calf on the outside is the extensor digitorum longus, running down the length of the tibia.

Here Lucchesi packs some clay under the rib cage to support it. Just under his thumb, you can see the serratus anterior muscles.

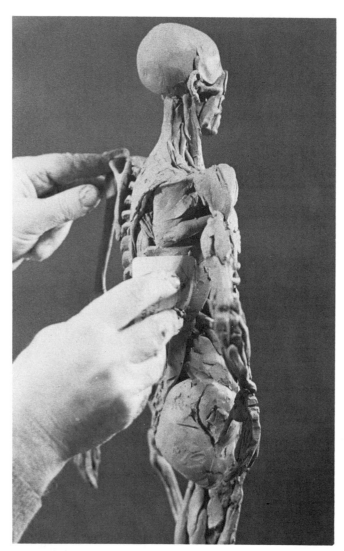

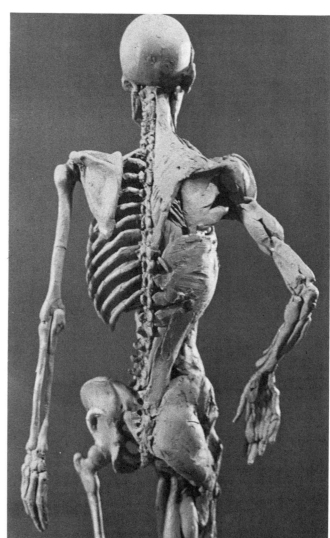

In back, he smooths the large latissimus dorsi, which attaches from all along the middle and lower spine up to the armpit under the teres major.

Here you can see the latissimus dorsi more clearly.

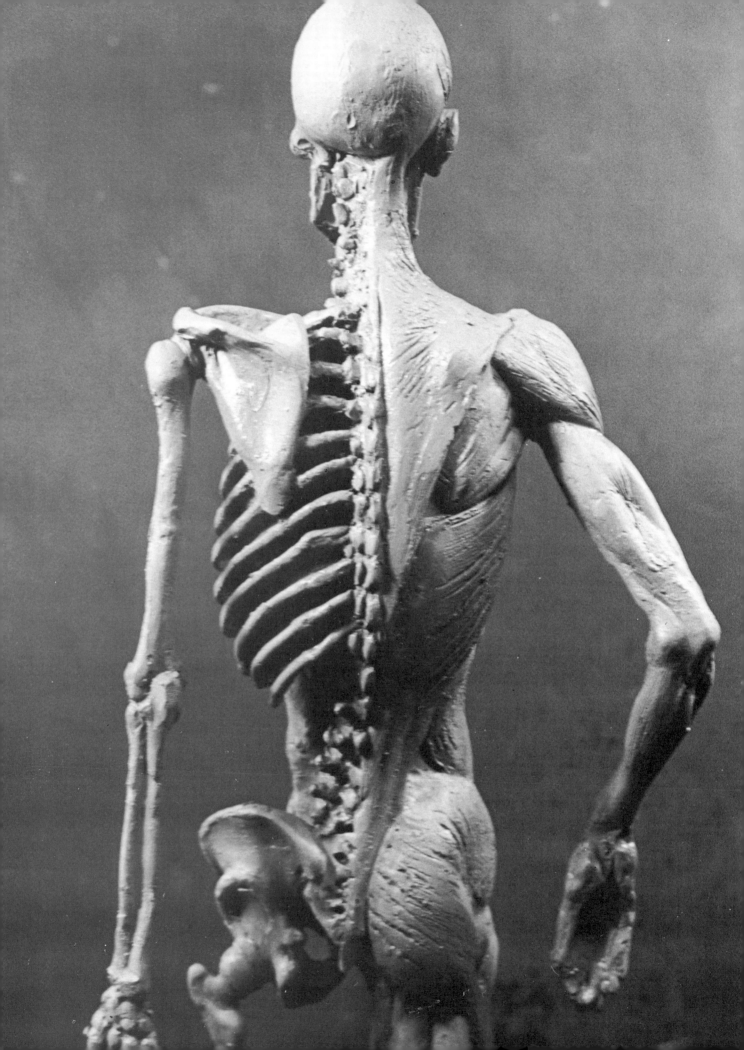

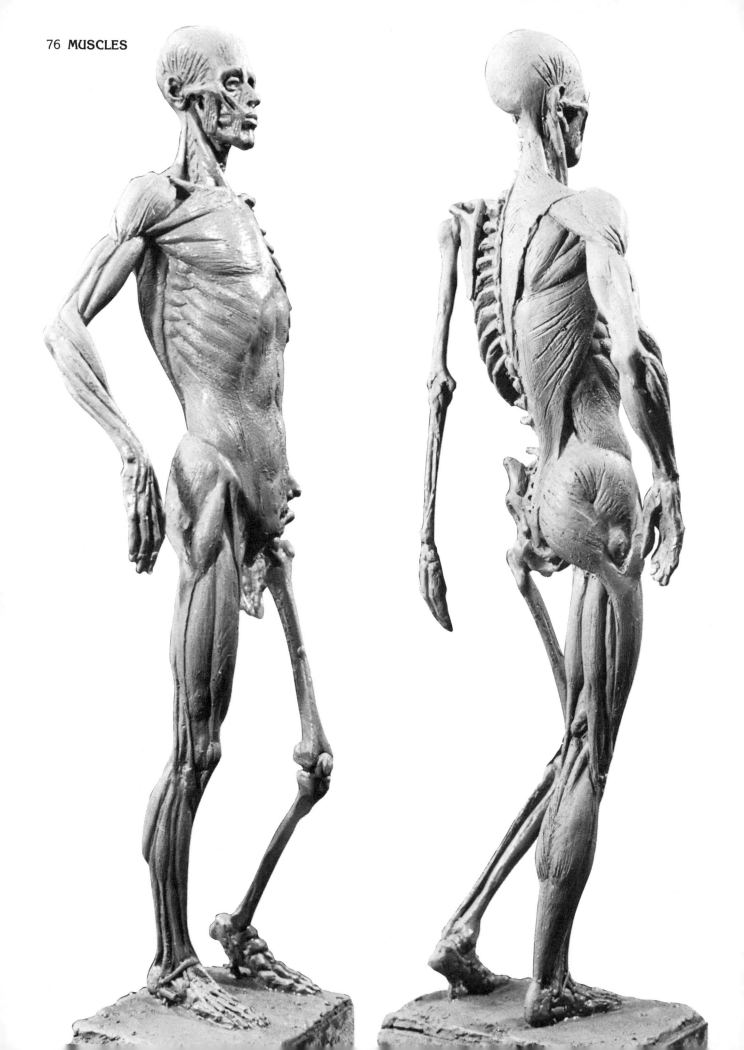

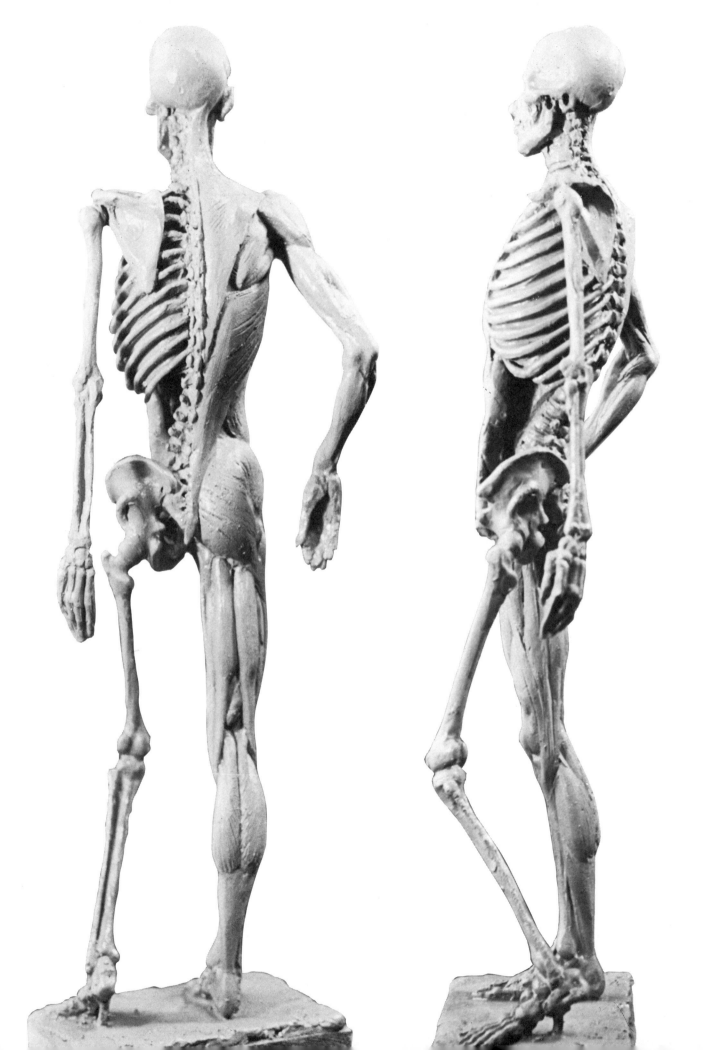

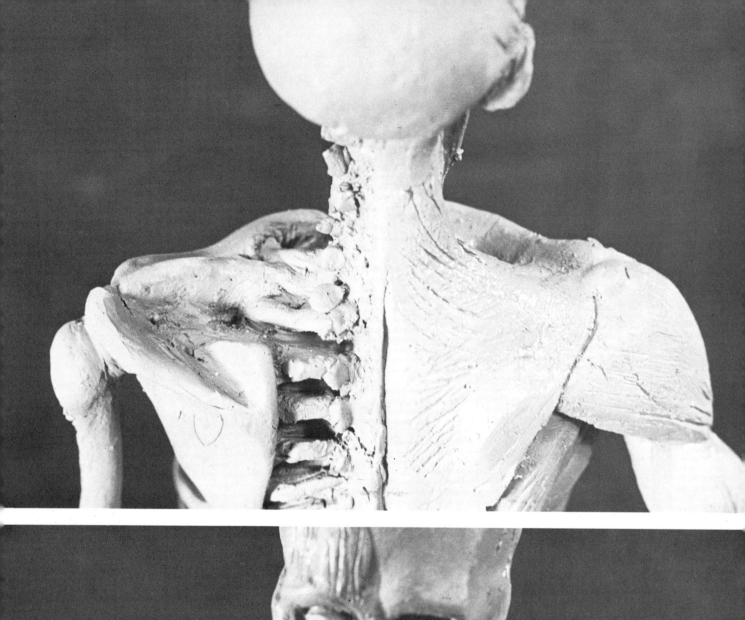

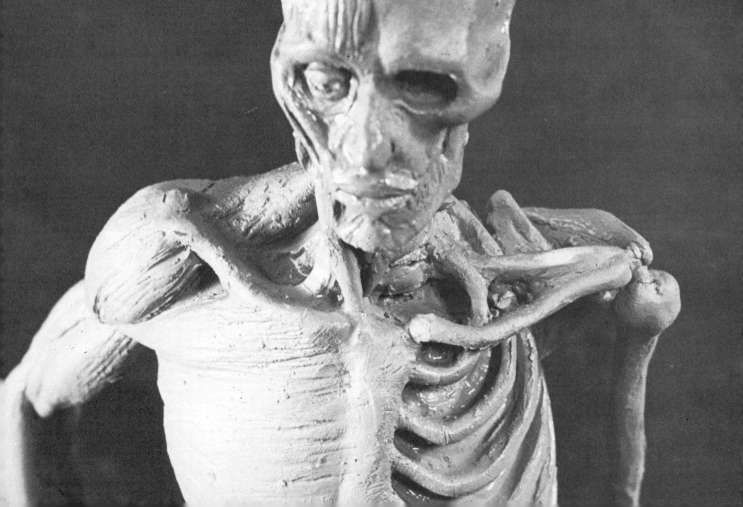

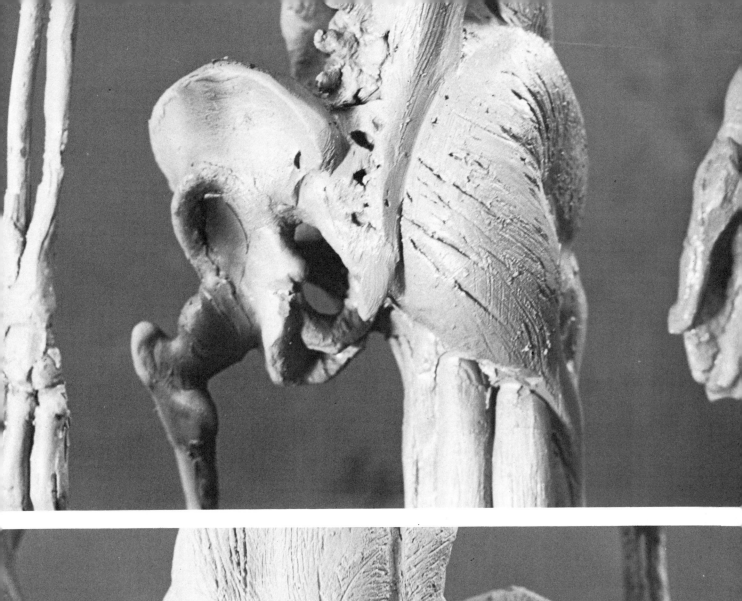

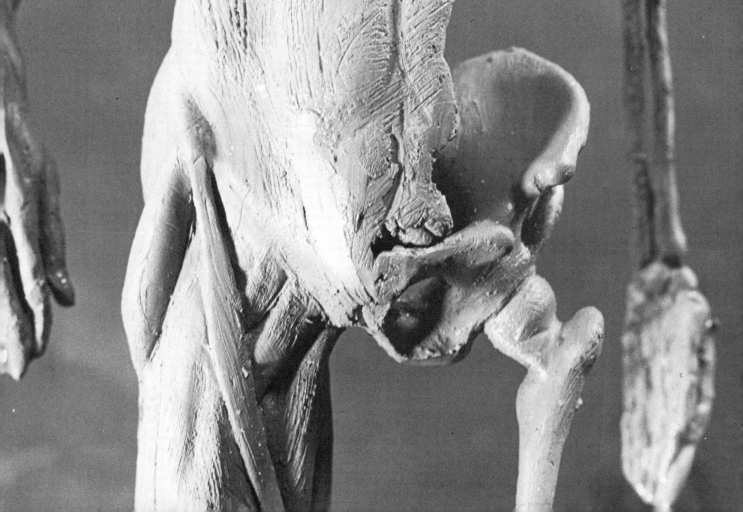

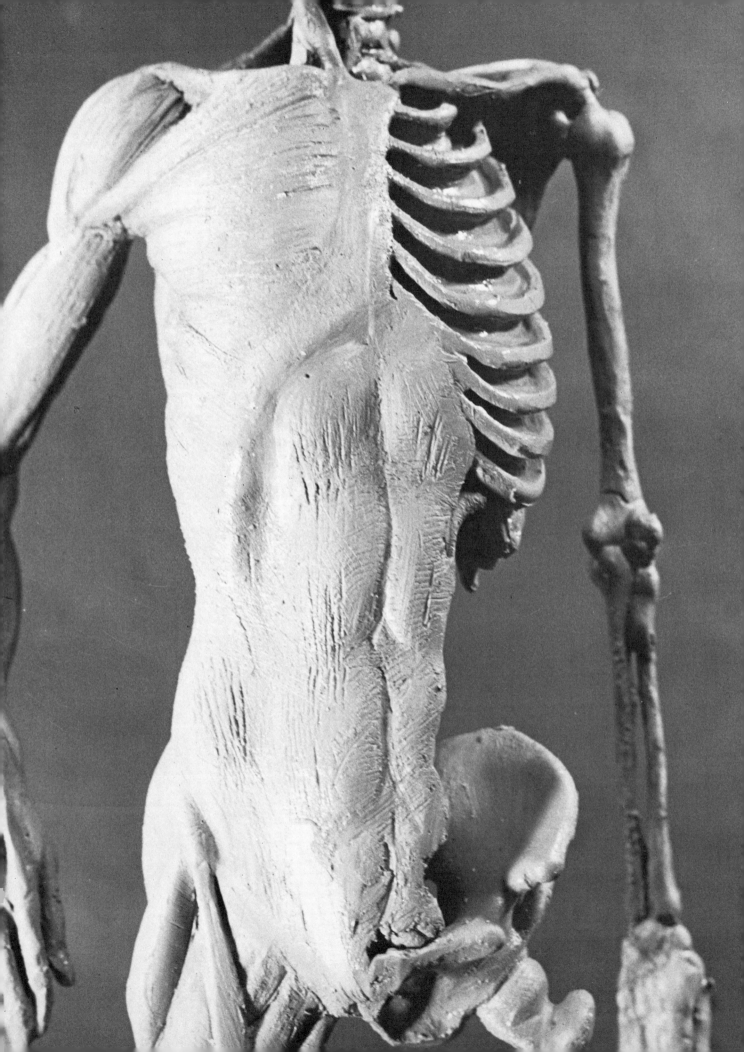

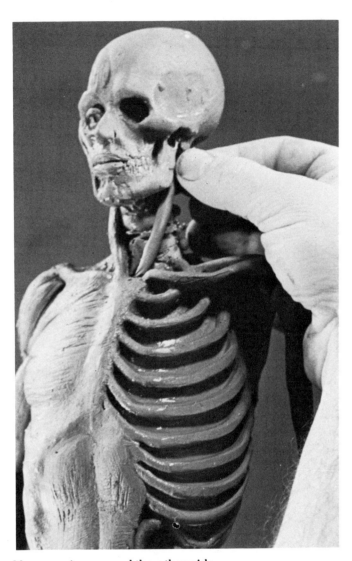

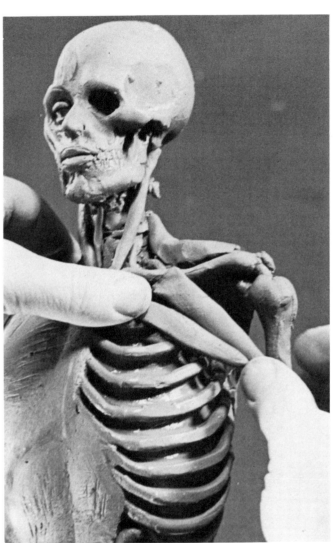

Now, moving around the other side of the figure, Lucchesi positions the sternocleidomastoideus. In front, covering the abdomen, is the rectus abdominis.

He lays in the start of the pectoralis major. You can see the front of the trapezius covering the shoulder.

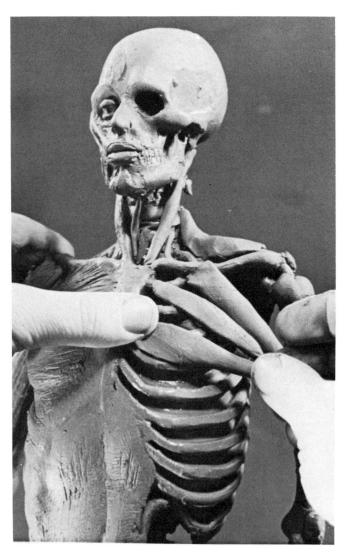

More pectoralis major.

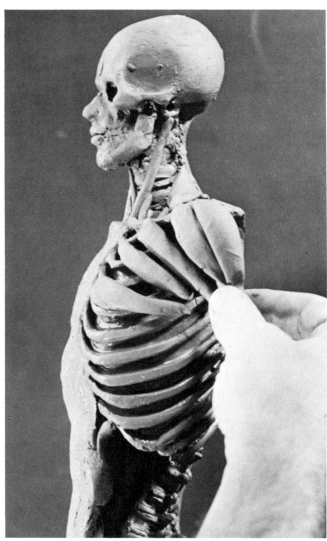

He places the front and side heads of
the three-headed deltoideus.

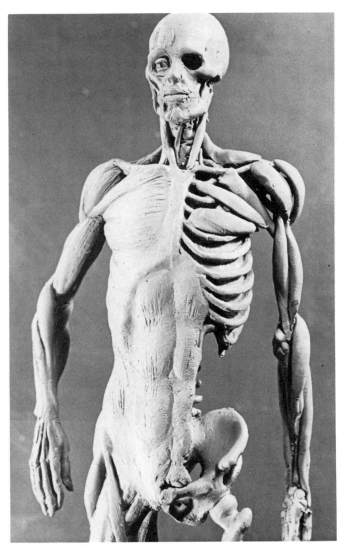

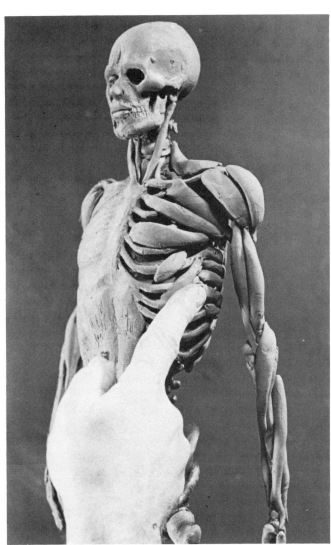

Below the deltoid is the two-headed biceps brachii. Running over the elbow is the brachioradialis, and behind it, the extensor carpi radialis longus.

Lucchesi weaves the serratus muscle into the rib cage.

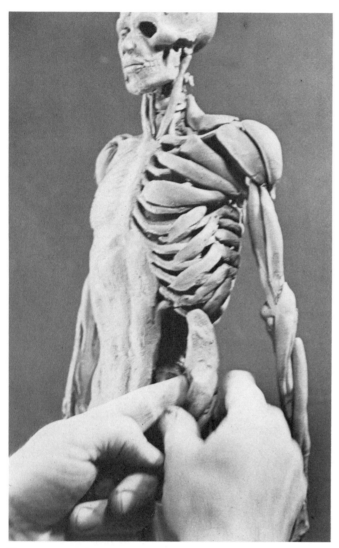

He positions the external oblique,
obliquus externus.

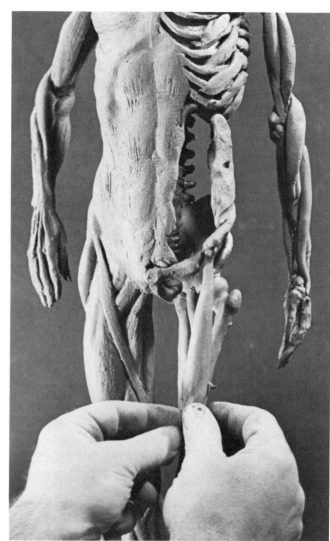

Moving down to the leg, he runs the
rectus femoris from the iliac crest
down to the end of the femur.

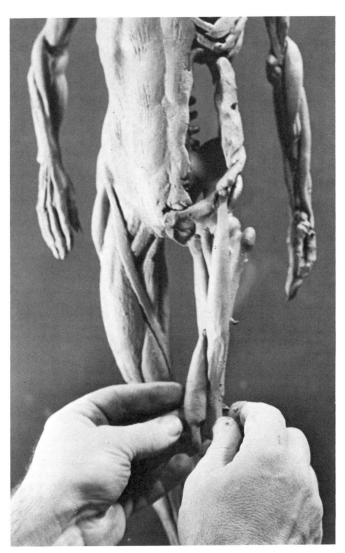

He adds the vastus medialis.

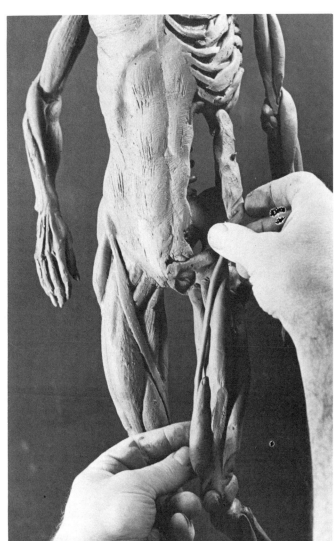

He runs the sartorius diagonally up the inside of the thigh to the iliac crest.

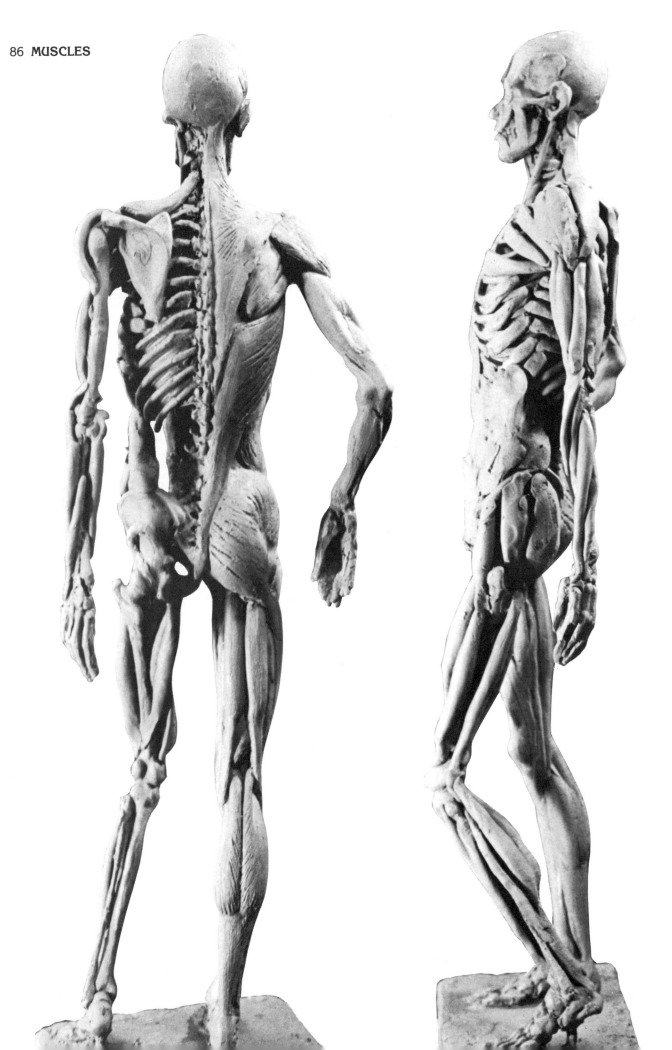

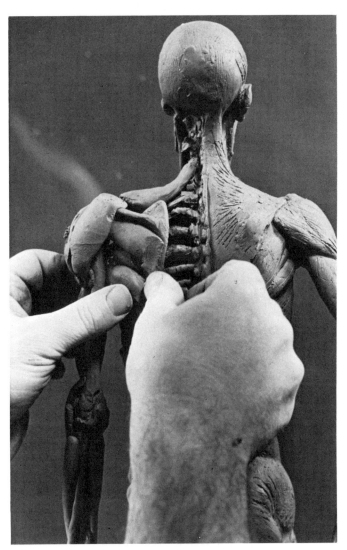

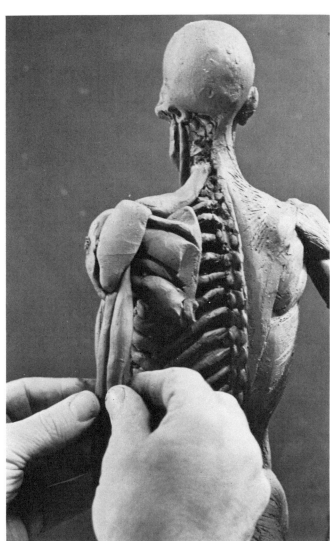

Here you can see the back head of the
deltoid. Below it, Lucchesi models the
infraspinatus and the teres minor;
the teres major is inserted under
the triceps.

He builds up the triceps.

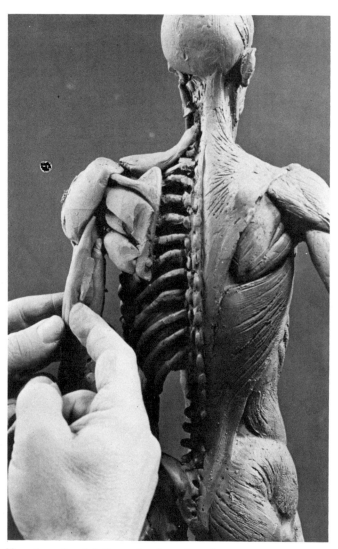

Here Lucchesi defines the three heads of the triceps.

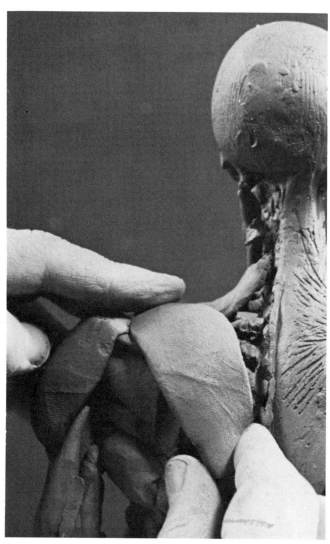

He lays on the other half of the trapezius.

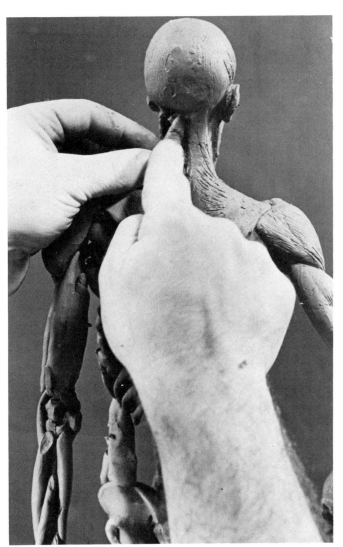

He runs the end of the trapezius up
to the base of the skull.

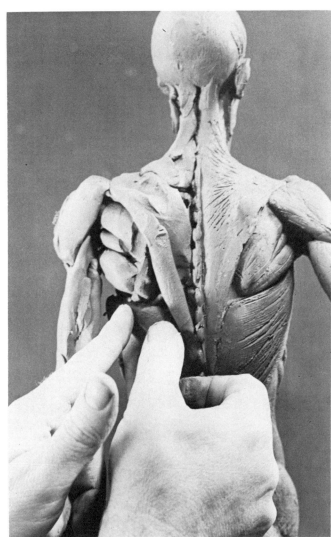

He positions the latissimus dorsi,
running its upper end under the
teres major.

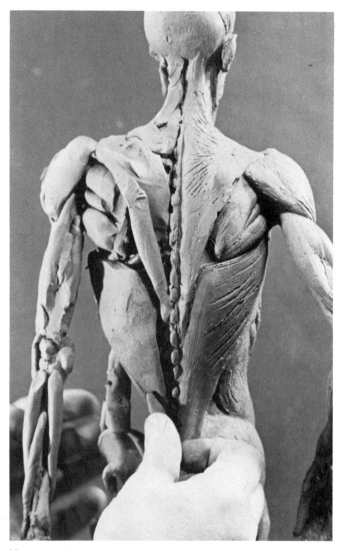

He extends the latissimus dorsi down
to its base at the end of the spine.

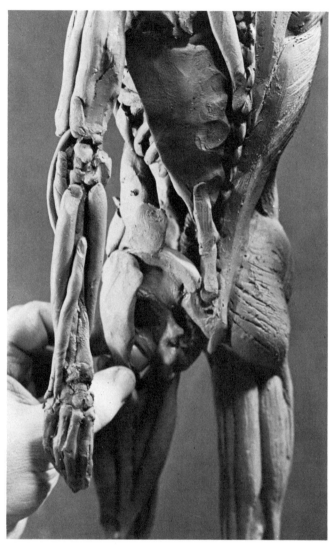

Moving down, he starts to build up the
gluteus maximus.

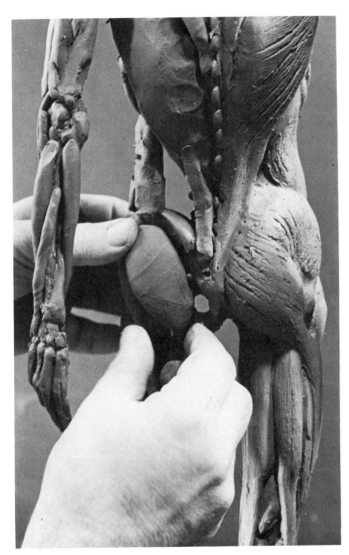

More gluteus maximus.

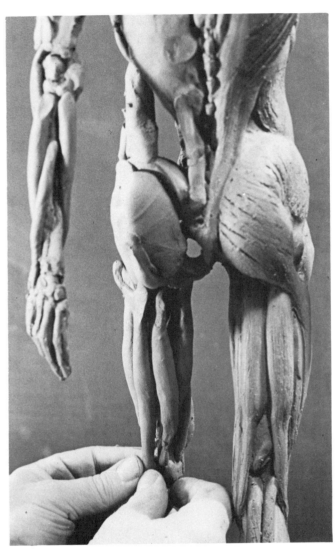

Further down, he adds the long head of the biceps femoris, and running along beside it on the inside, the semitendinosus. On the outside of the thigh you can see the vastus lateralis, and on the inside, the gracilis.

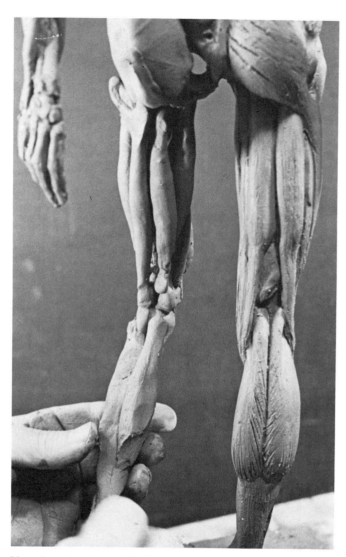

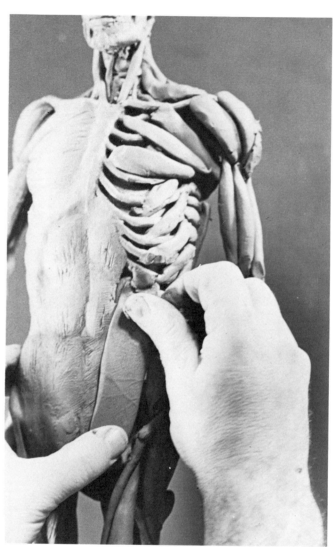

Here Lucchesi models the gastroc-nemius. When seen from the back, the inside bulge of the calf is a little lower than the outside, but when seen from the front, it is a little higher.

He lays on more rectus abdominis.

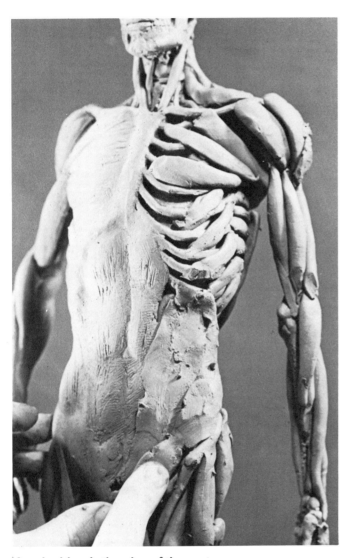

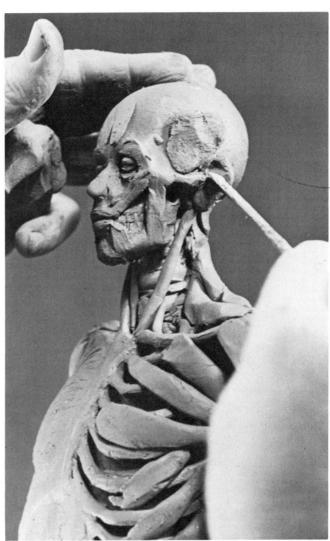

Here he blends the clay of the rectus abdominis into the external oblique.

With a wooden modeling tool, he moves up to model the details of the ear.

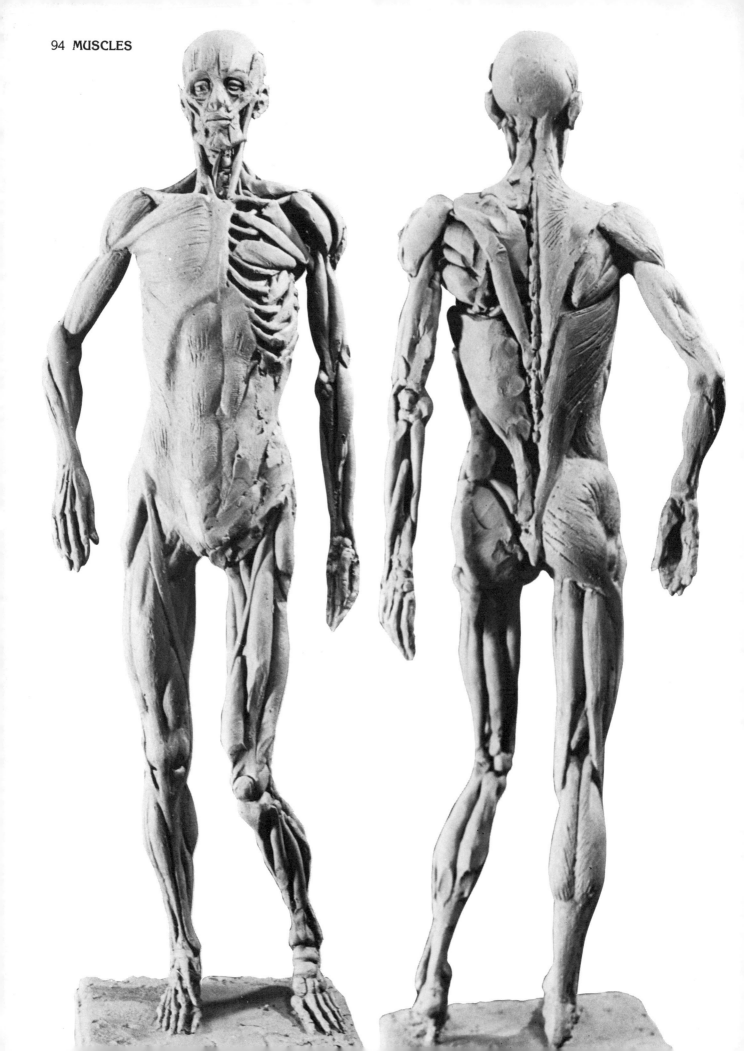

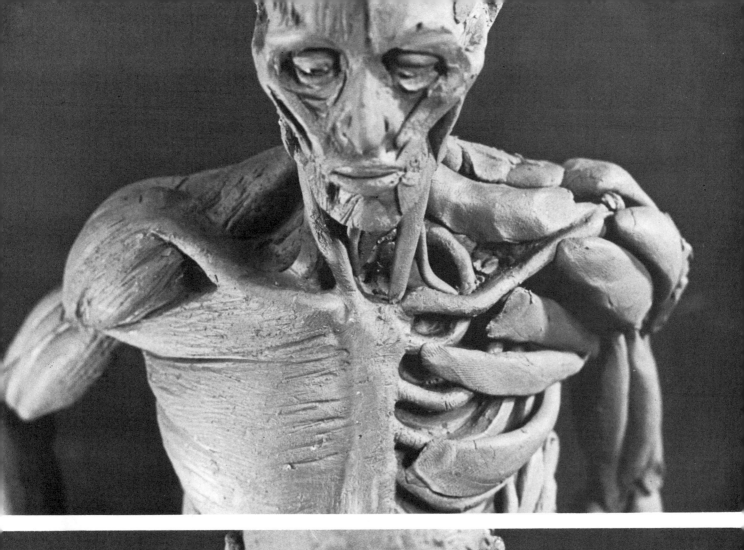

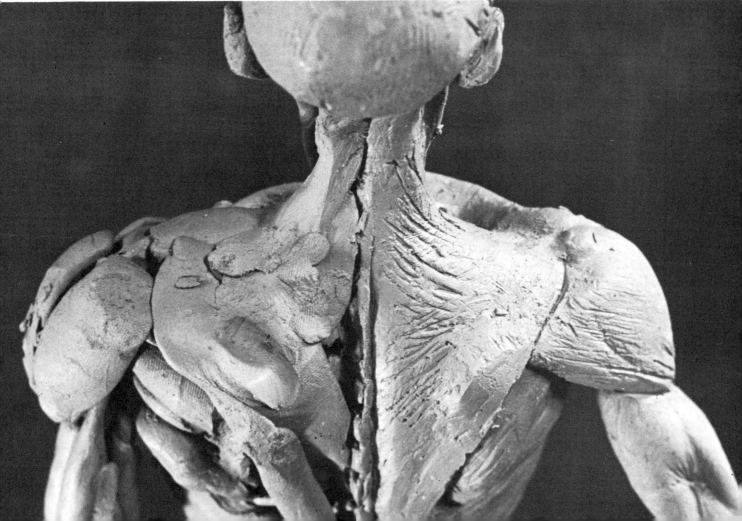

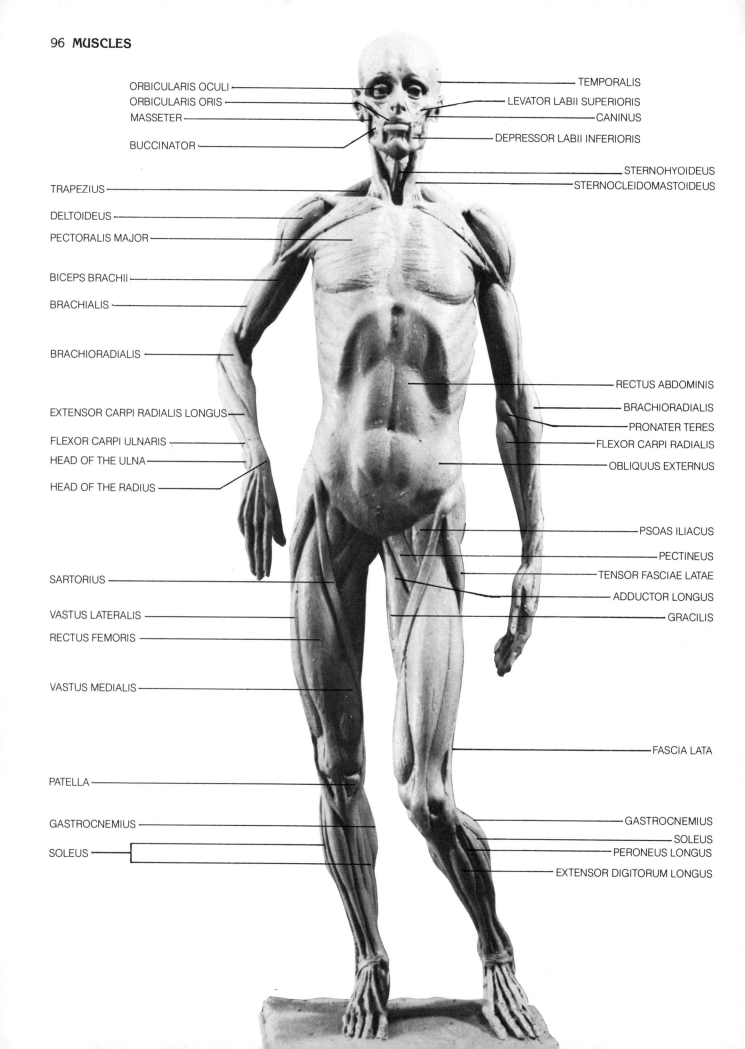

ORBICULARIS OCULI

ORBICULARIS ORIS

MASSETER

BUCCINATOR

TRAPEZIUS

DELTOIDEUS

PECTORALIS MAJOR

BICEPS BRACHII

BRACHIALIS

BRACHIORADIALIS

EXTENSOR CARPI RADIALIS LONGUS

FLEXOR CARPI ULNARIS

HEAD OF THE ULNA

HEAD OF THE RADIUS

SARTORIUS

VASTUS LATERALIS

RECTUS FEMORIS

VASTUS MEDIALIS

PATELLA

GASTROCNEMIUS

SOLEUS

TEMPORALIS

LEVATOR LABII SUPERIORIS

CANINUS

DEPRESSOR LABII INFERIORIS

STERNOHYOIDEUS

STERNOCLEIDOMASTOIDEUS

RECTUS ABDOMINIS

BRACHIORADIALIS

PRONATER TERES

FLEXOR CARPI RADIALIS

OBLIQUUS EXTERNUS

PSOAS ILIACUS

PECTINEUS

TENSOR FASCIAE LATAE

ADDUCTOR LONGUS

GRACILIS

FASCIA LATA

GASTROCNEMIUS

SOLEUS

PERONEUS LONGUS

EXTENSOR DIGITORUM LONGUS

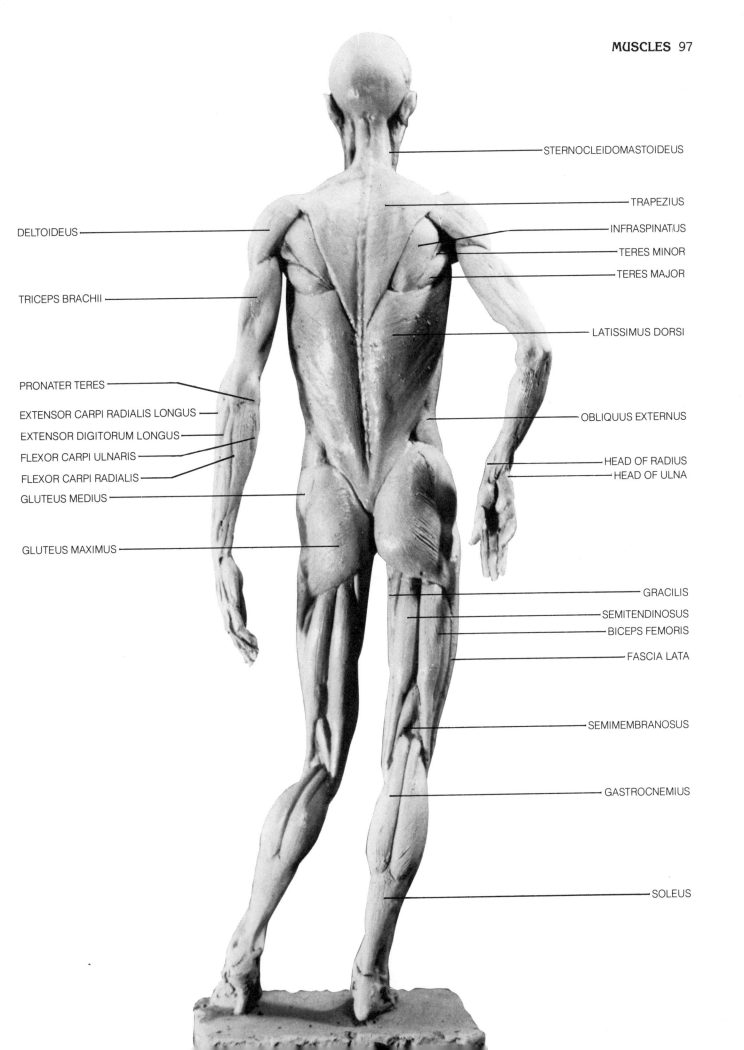

STERNOCLEIDOMASTOIDEUS

TRAPEZIUS

INFRASPINATUS

TERES MINOR

TERES MAJOR

LATISSIMUS DORSI

OBLIQUUS EXTERNUS

HEAD OF RADIUS

HEAD OF ULNA

GRACILIS

SEMITENDINOSUS

BICEPS FEMORIS

FASCIA LATA

SEMIMEMBRANOSUS

GASTROCNEMIUS

SOLEUS

DELTOIDEUS

TRICEPS BRACHII

PRONATER TERES

EXTENSOR CARPI RADIALIS LONGUS

EXTENSOR DIGITORUM LONGUS

FLEXOR CARPI ULNARIS

FLEXOR CARPI RADIALIS

GLUTEUS MEDIUS

GLUTEUS MAXIMUS

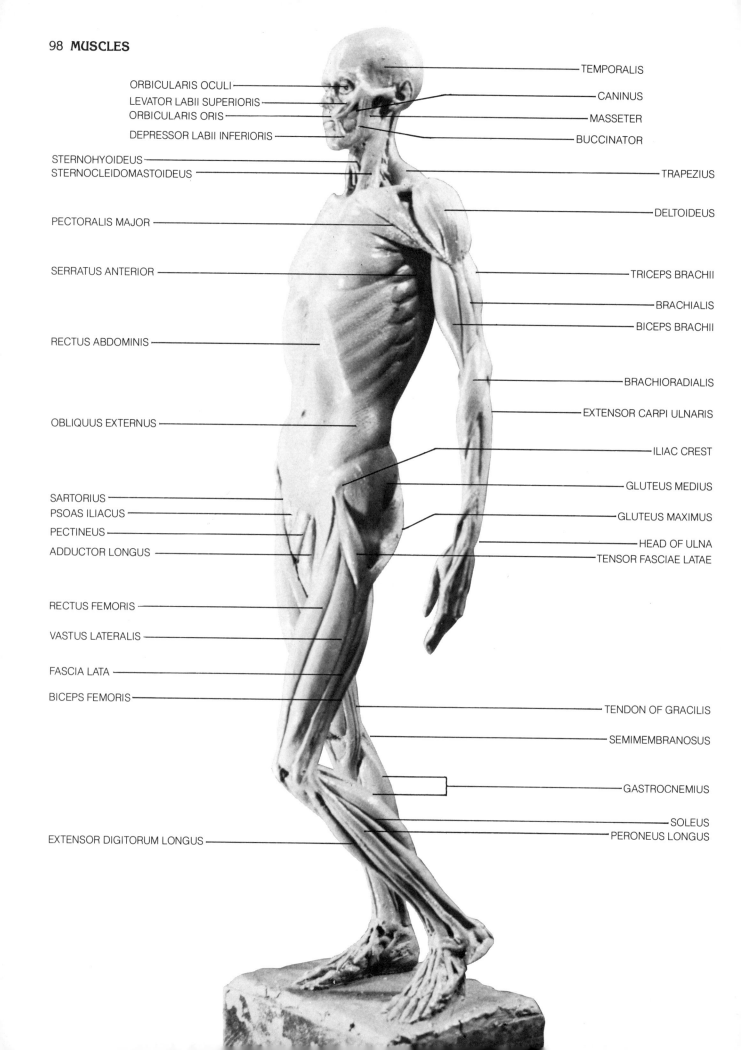

ORBICULARIS OCULI

LEVATOR LABII SUPERIORIS

ORBICULARIS ORIS

DEPRESSOR LABII INFERIORIS

STERNOHYOIDEUS

STERNOCLEIDOMASTOIDEUS

PECTORALIS MAJOR

SERRATUS ANTERIOR

RECTUS ABDOMINIS

OBLIQUUS EXTERNUS

SARTORIUS

PSOAS ILIACUS

PECTINEUS

ADDUCTOR LONGUS

RECTUS FEMORIS

VASTUS LATERALIS

FASCIA LATA

BICEPS FEMORIS

EXTENSOR DIGITORUM LONGUS

TEMPORALIS

CANINUS

MASSETER

BUCCINATOR

TRAPEZIUS

DELTOIDEUS

TRICEPS BRACHII

BRACHIALIS

BICEPS BRACHII

BRACHIORADIALIS

EXTENSOR CARPI ULNARIS

ILIAC CREST

GLUTEUS MEDIUS

GLUTEUS MAXIMUS

HEAD OF ULNA

TENSOR FASCIAE LATAE

TENDON OF GRACILIS

SEMIMEMBRANOSUS

GASTROCNEMIUS

SOLEUS

PERONEUS LONGUS

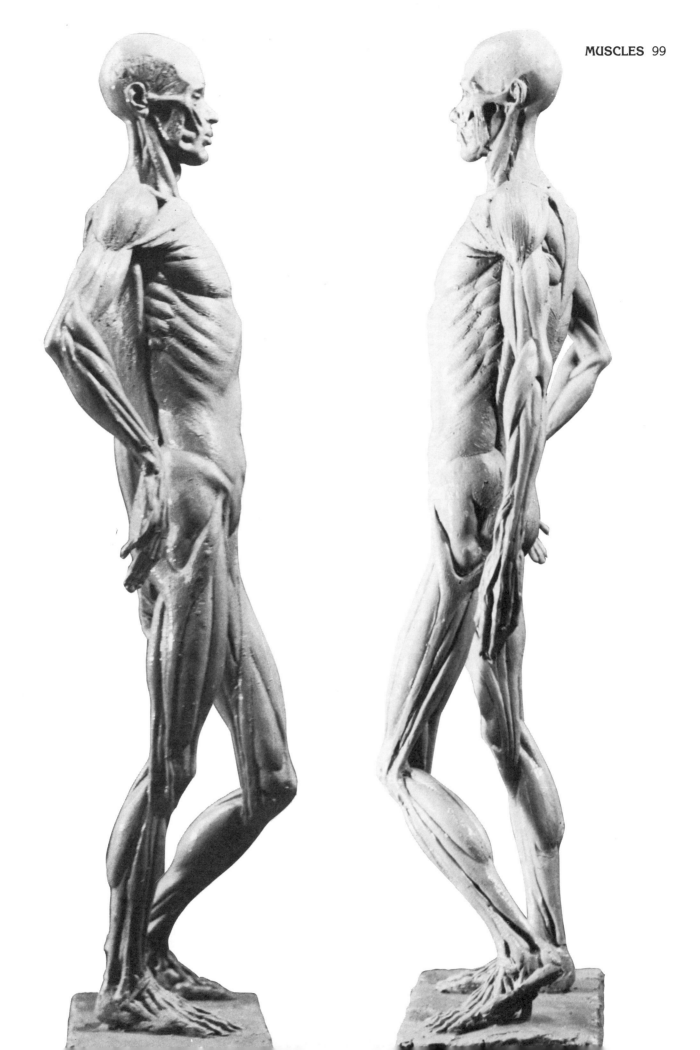

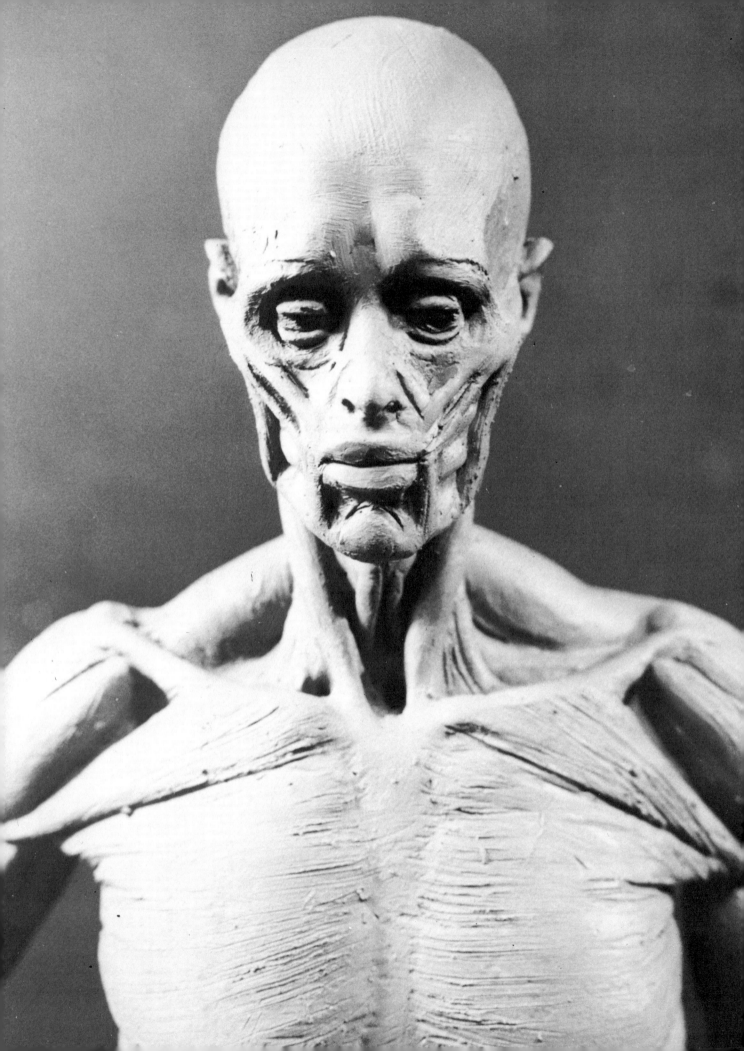

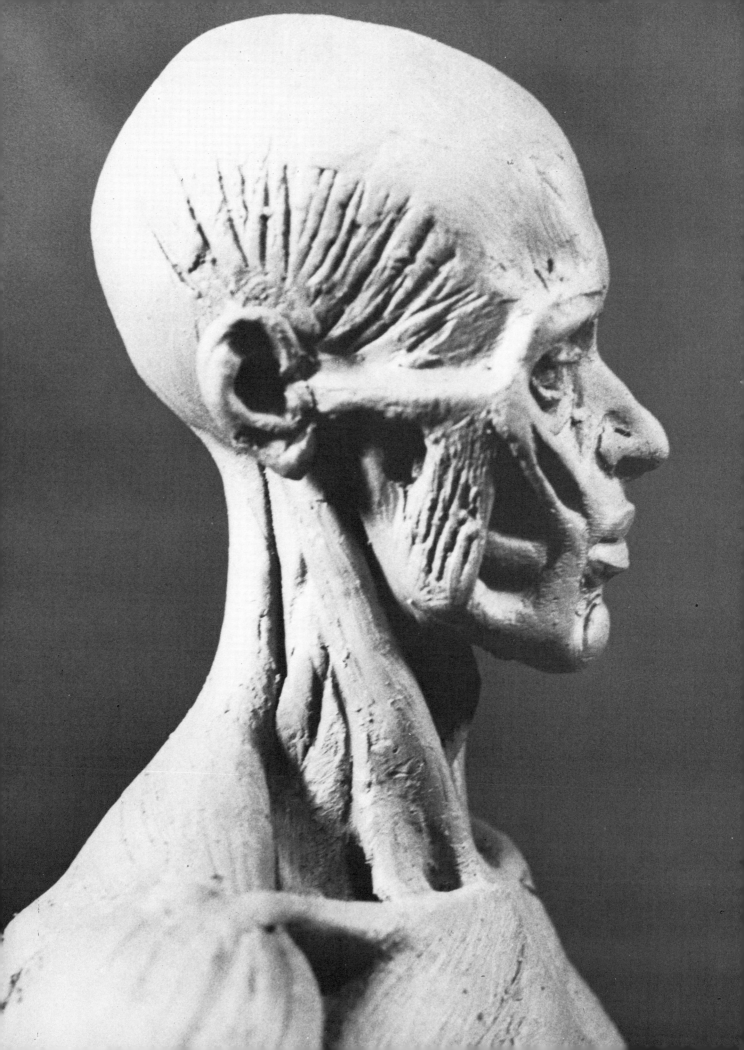

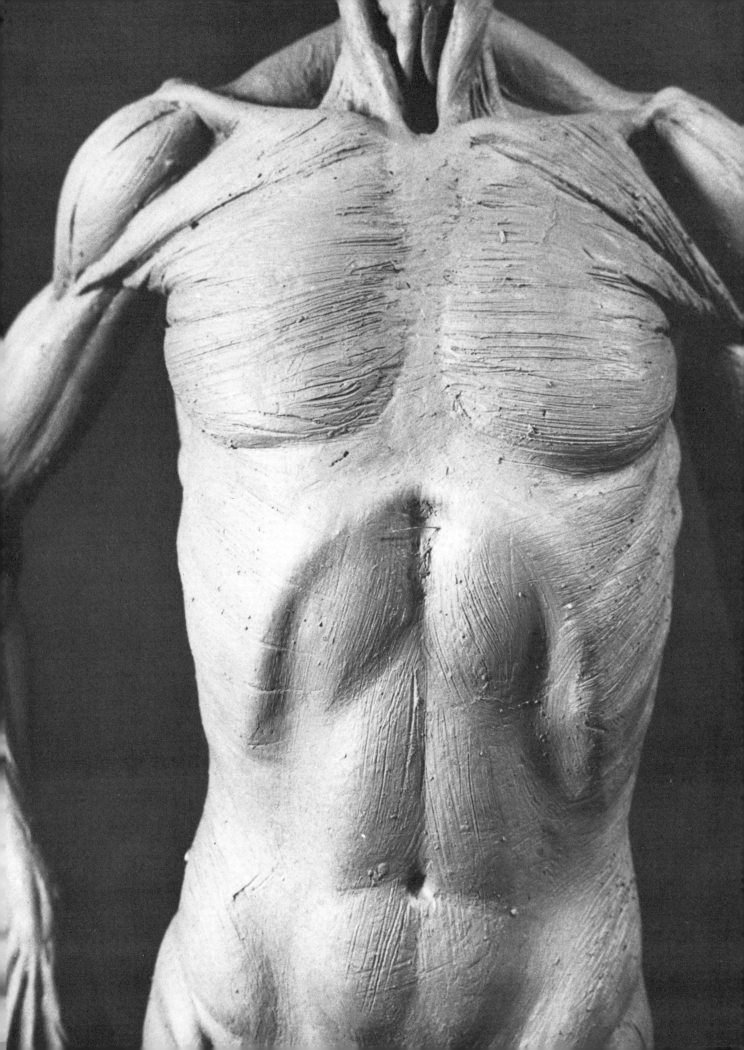

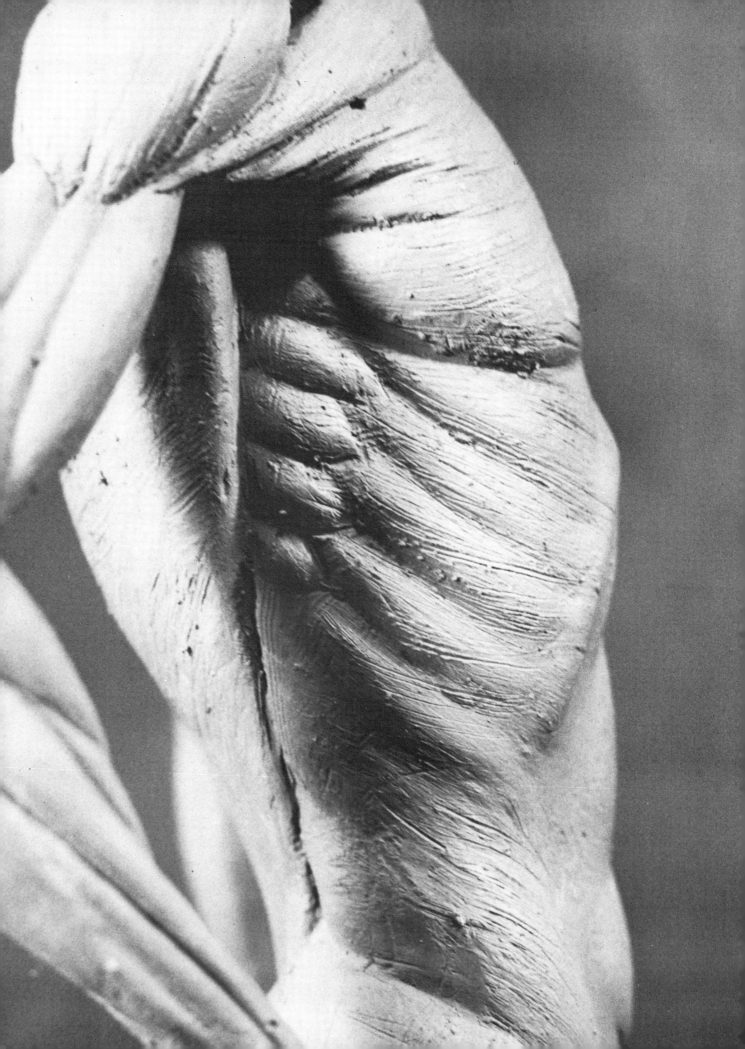

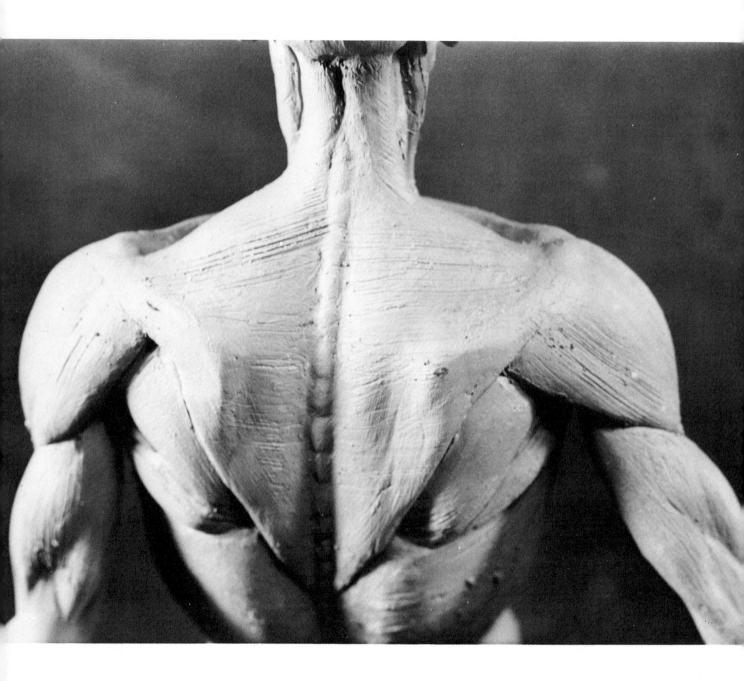

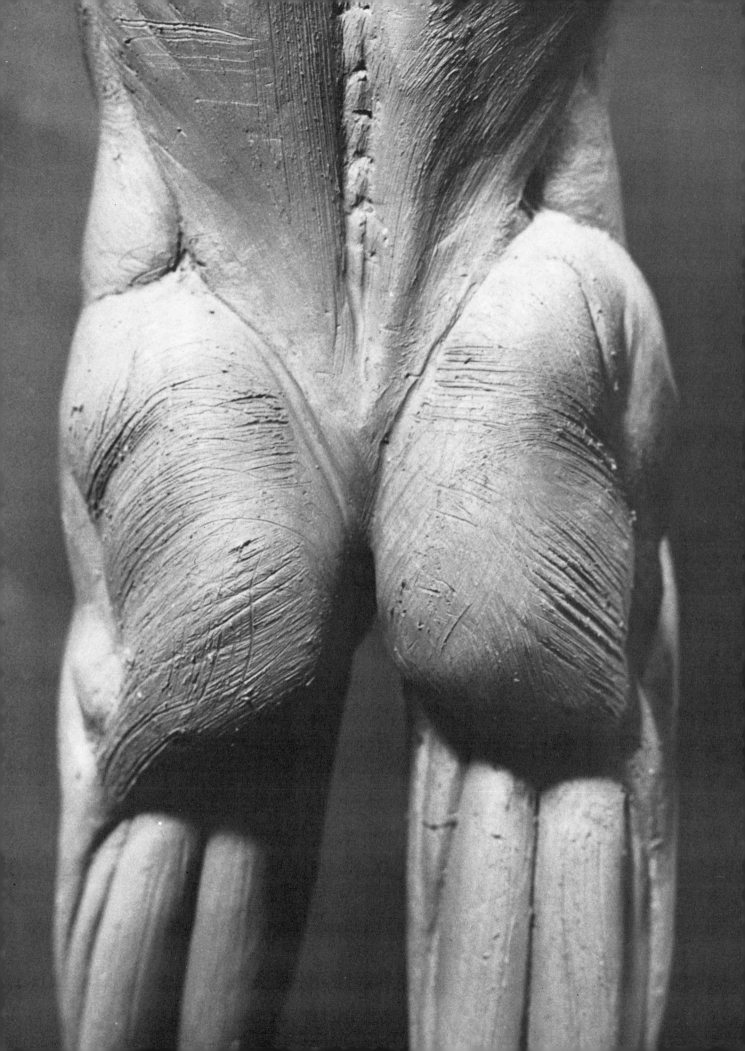

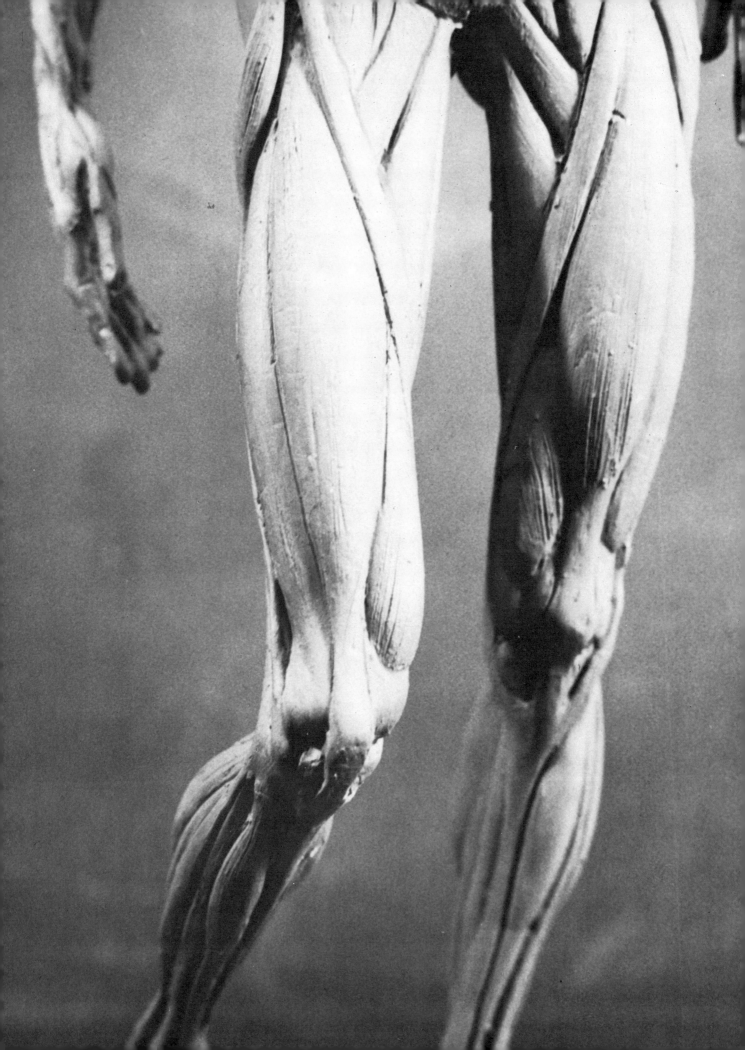

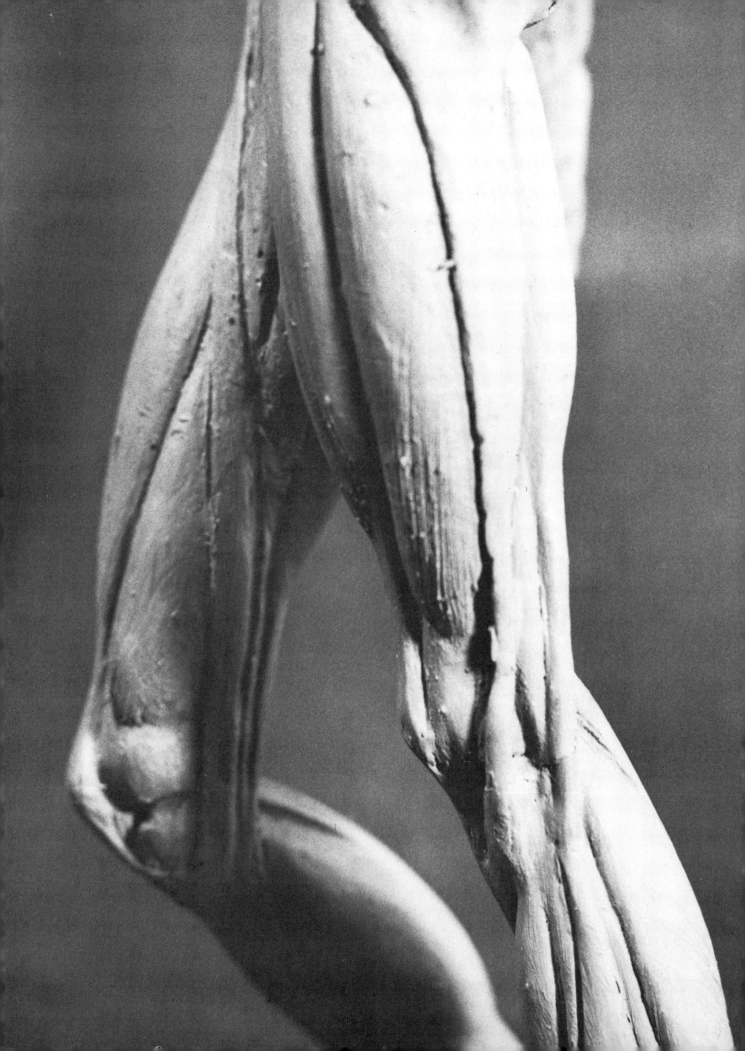

Female Figure

In this section, Lucchesi definitely establishes the sex of the figure by adding deposits of fatty tissue to hips, thighs, buttocks, breasts, and various other points on the body, such as above the knees. Aside from a more delicate bone structure, wider pelvis, and softer muscles, what most differentiates the female from the male is her strategic arrangement of subcutaneous fat, better known as her "figure."

After he has blended the fatty tissue into the muscles beneath, Lucchesi adds the body's envelope, the skin, and its crowning adornment, the hair.

To make the skin, Lucchesi slaps a ball of clay either between his hands or against a tabletop or the floor until he forms a thin layer. He applies this over the muscles, working the clay in gently so as not to mar the modeling beneath. He pulls the surface together with a brush, used both wet and dry, which smooths and blends the clay until it has the soft, even texture of skin.

The hair is added in clay coils, worked together to form large masses that have weight and volume. The hair, like the skin, is brushed with wet and dry brushes to blend and soften the clay and pull the surface together.

Finally, the sculptor's dream comes true as his Galatea descends from her pedestal to embrace her creator. A touch of whimsy, perhaps, but ask anyone who has ever breathed life into a lump of wet clay whether there isn't some truth to that story!

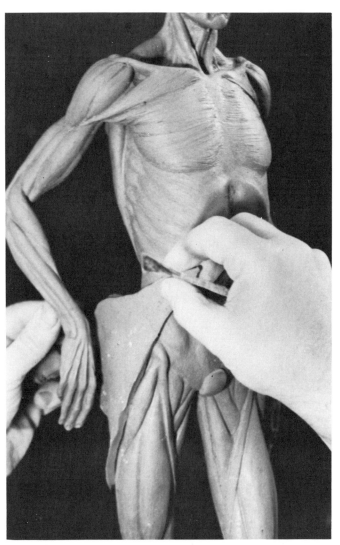

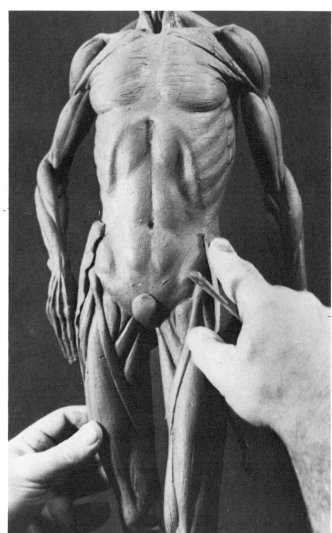

First Lucchesi places a layer of fatty tissue over the pubic bone and the hips.

He blends the hip clay into the external oblique.

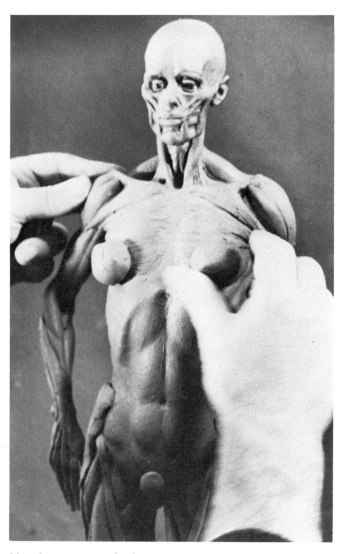

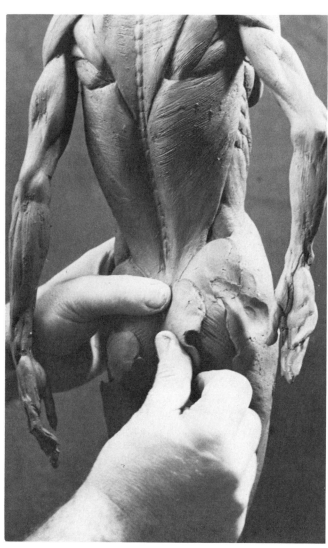

Now he positions the breasts on top of the pectoral muscles.

Moving around to the back, he pads out the gluteus muscles.

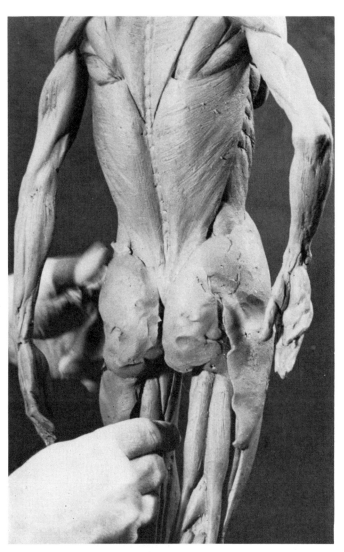

Then he works this fatty area down the outside of the thigh.

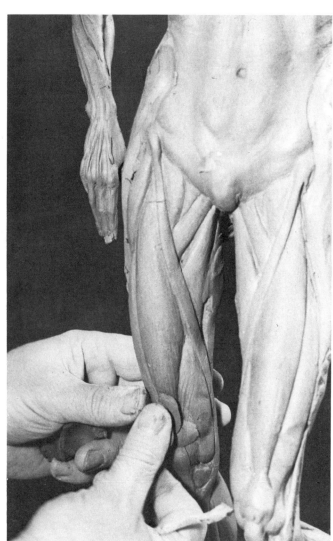

He places a ball of fat just above the kneecap.

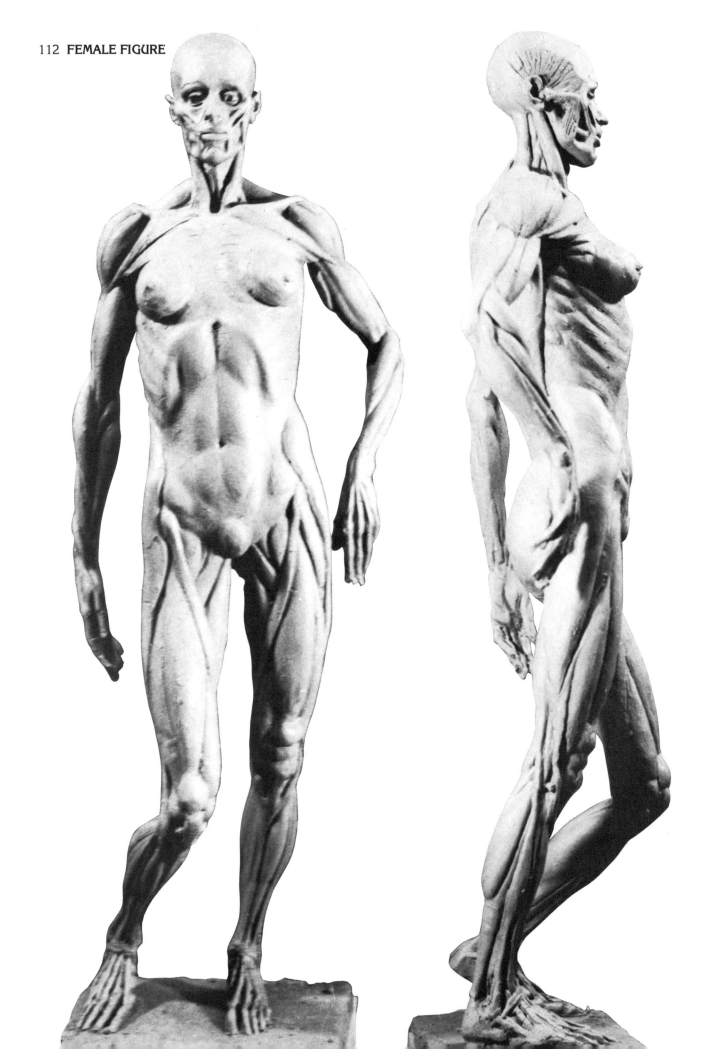

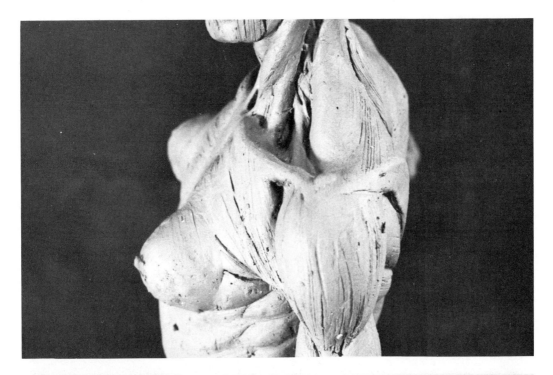

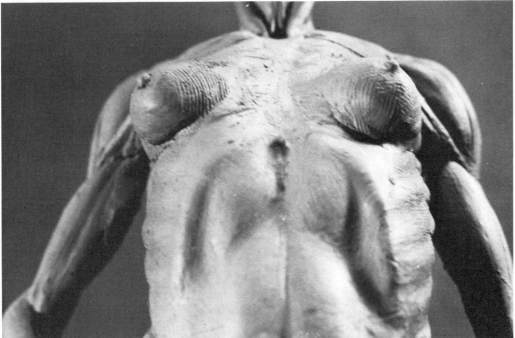

(Top) In this side view, notice how the breast attaches to the two visible bulges of the pectoral muscle.

(Above) From this angle you can see how the breasts ride on top of the rib cage.

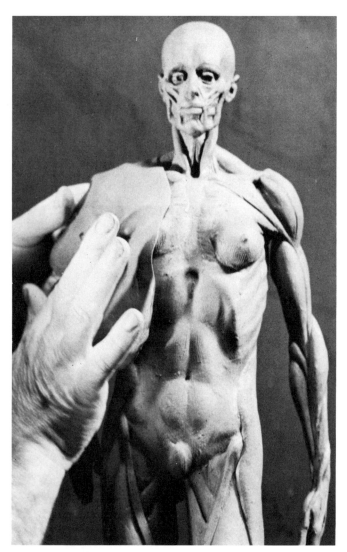

Now Lucchesi begins to cover the figure with "skin." He flattens the clay like a pancake, by either slapping it between his hands or throwing it down on a flat surface such as a tabletop.

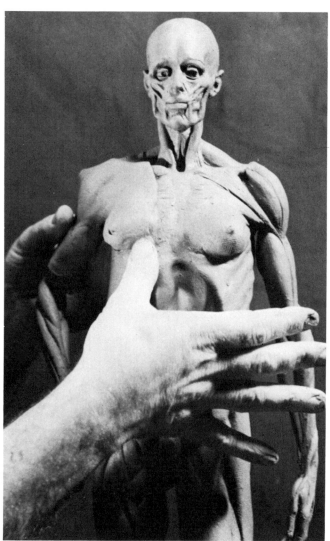

Carefully, he presses the thin layer of clay over the contours of the figure.

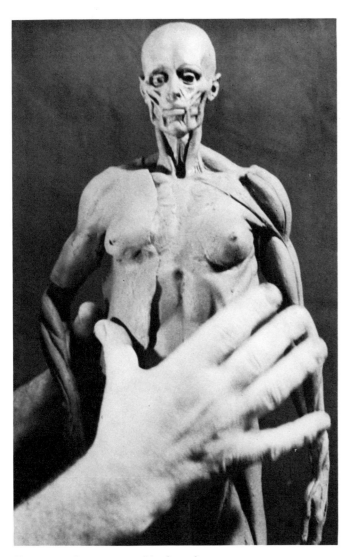

Using gentle pressure, his thumbs move over the surface, working the clay into the body beneath.

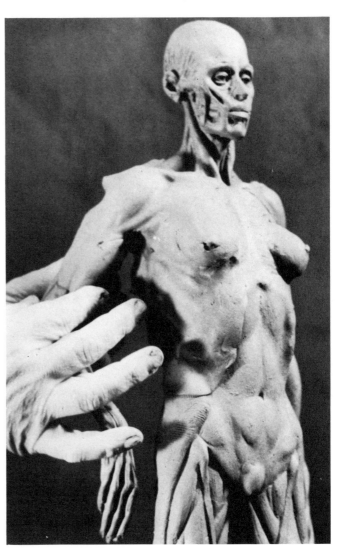

Here he wraps the clay around the muscles of the arm.

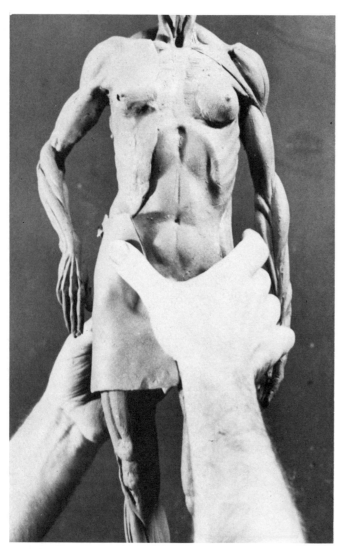

Lucchesi now covers the fatty tissue
of hip and thigh with skin.

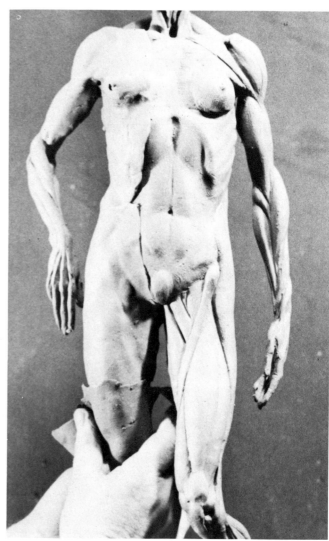

He moves down the leg, wrapping
it in skin.

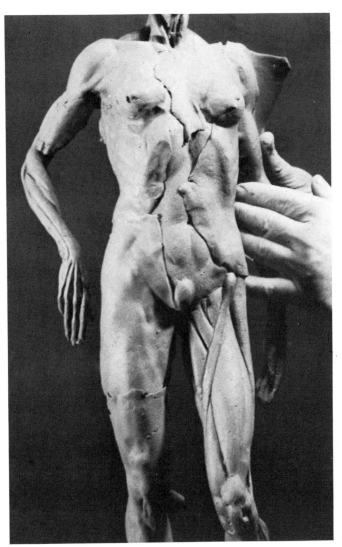

Here he covers the arm on the other side.

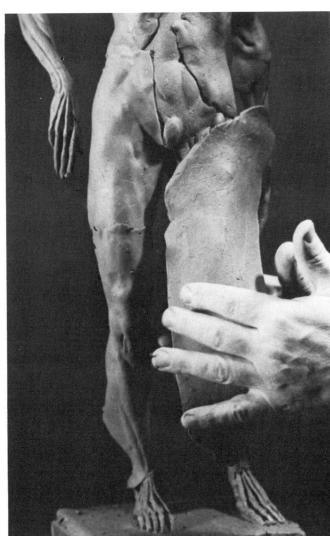

And the leg.

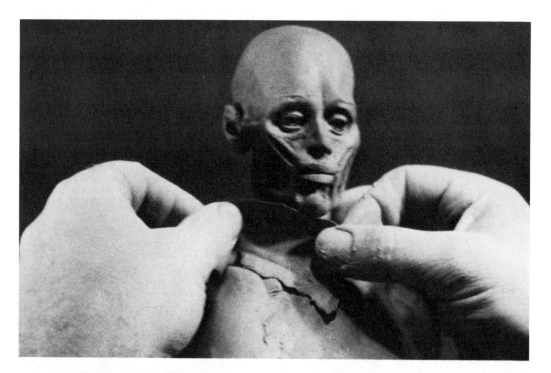

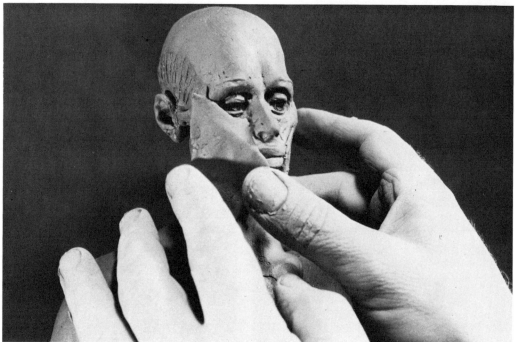

(Top) He delicately covers the neck with skin.

(Above) And now the face.

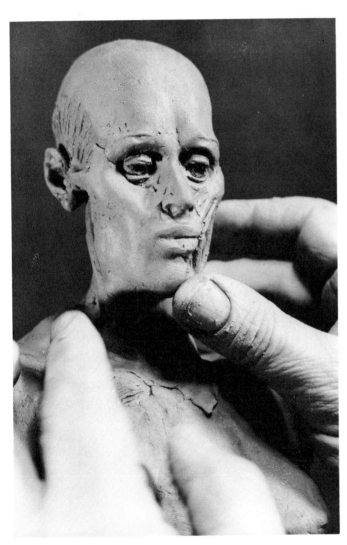

He blends the skin into the facial structure beneath, being careful not to lose the forms.

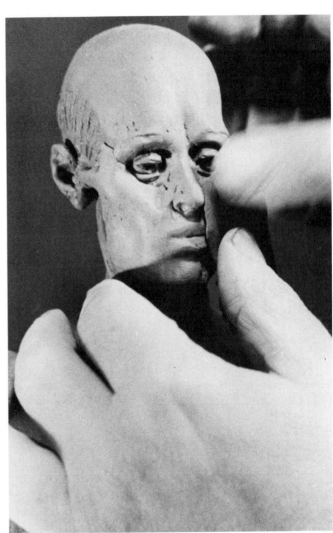

He uses sweeps of the thumb to work the clay together.

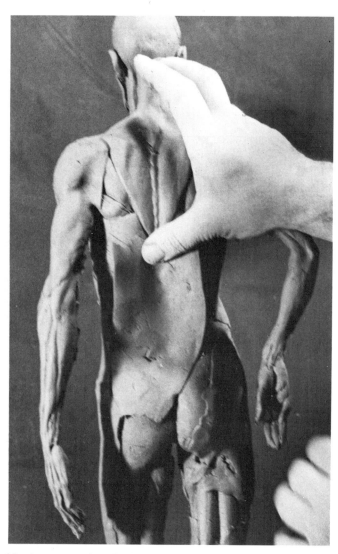

Moving around to the back, he covers the spine.

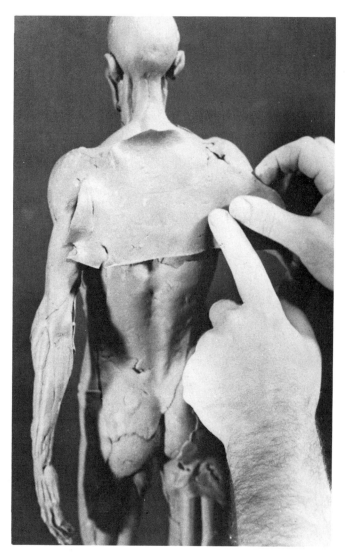

And the trapezius and shoulder blades.

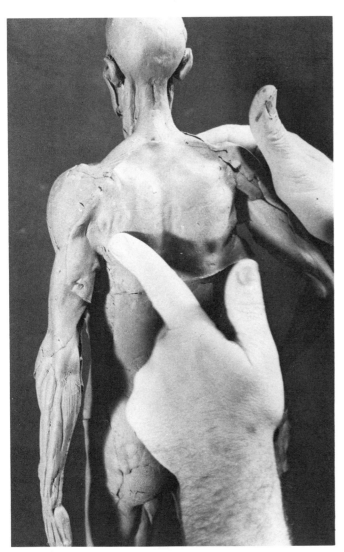

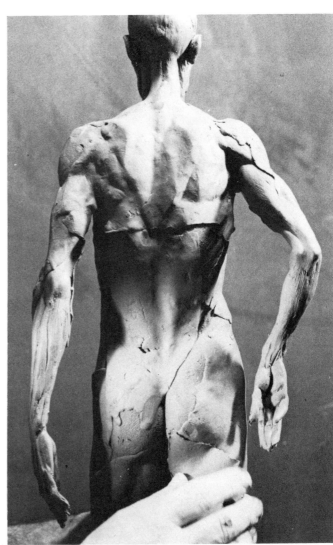

He works the clay of the skin into the forms beneath to define the anatomical structure.

He continues to work his way down the figure, here adding clay to the back of the thigh.

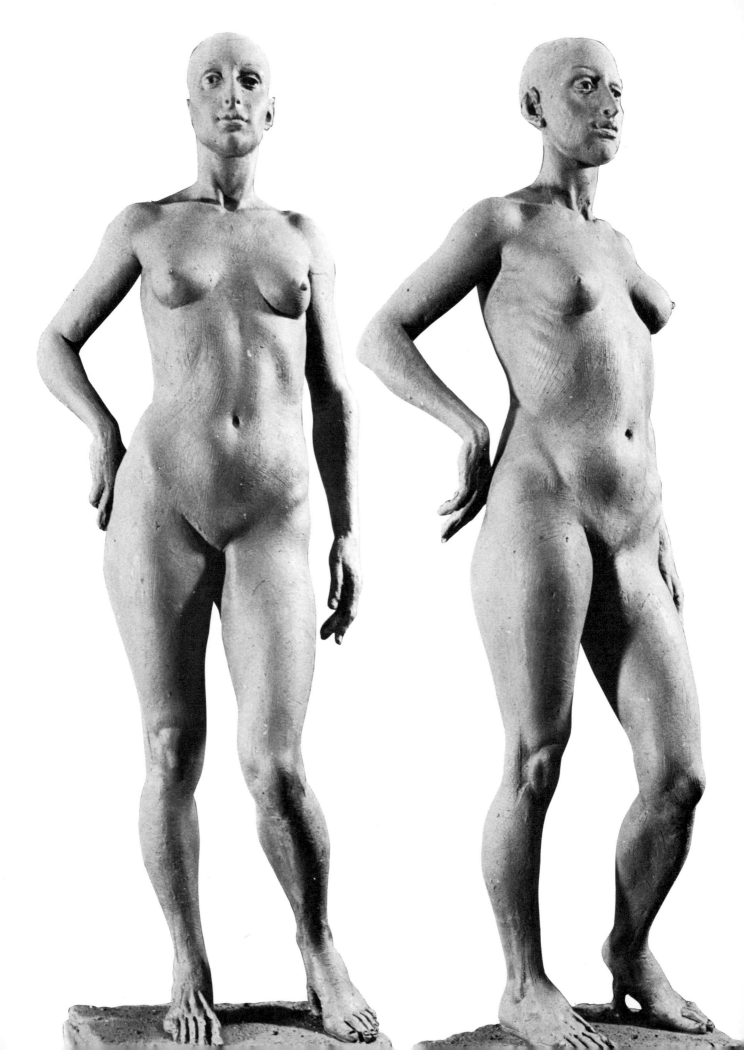

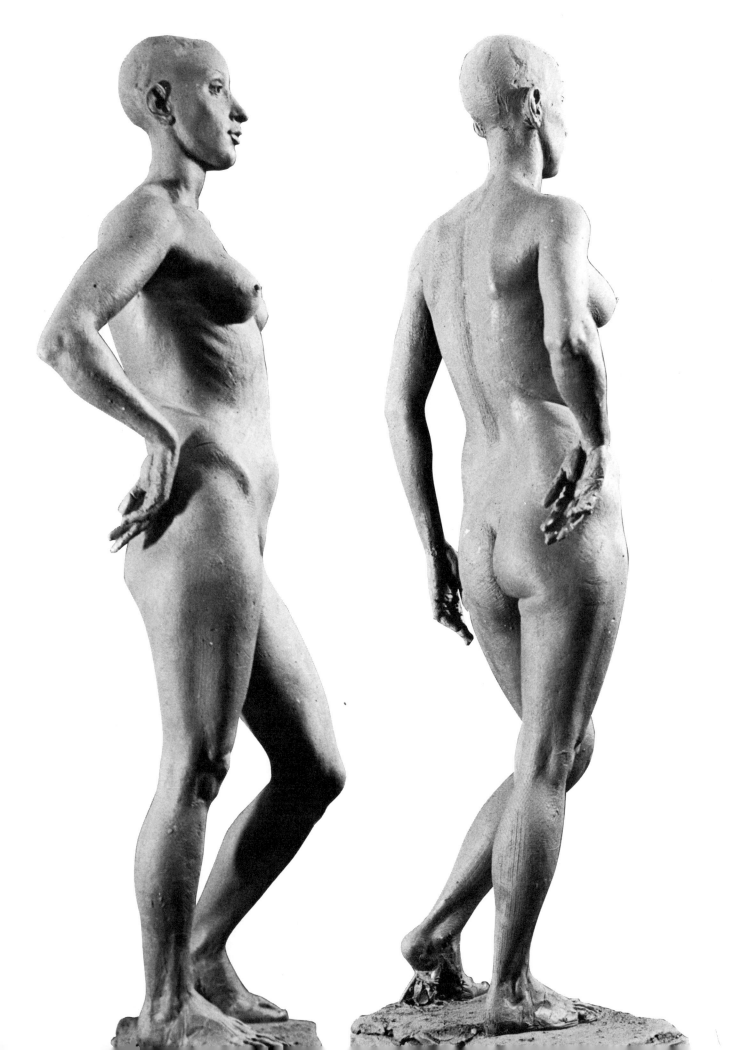

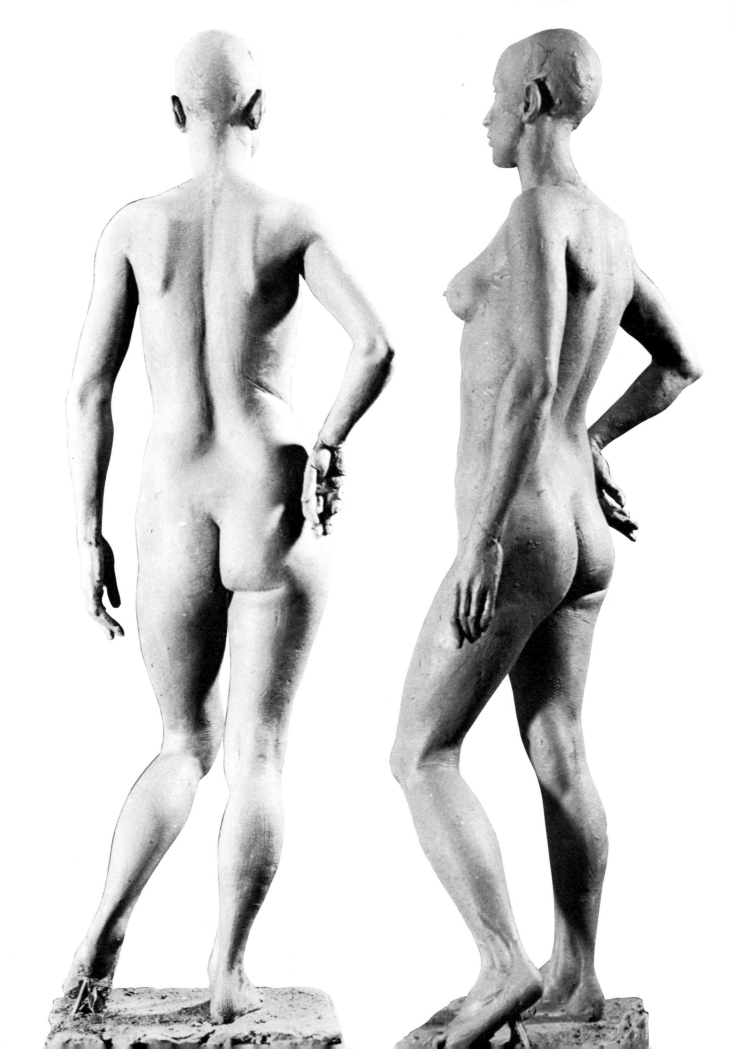

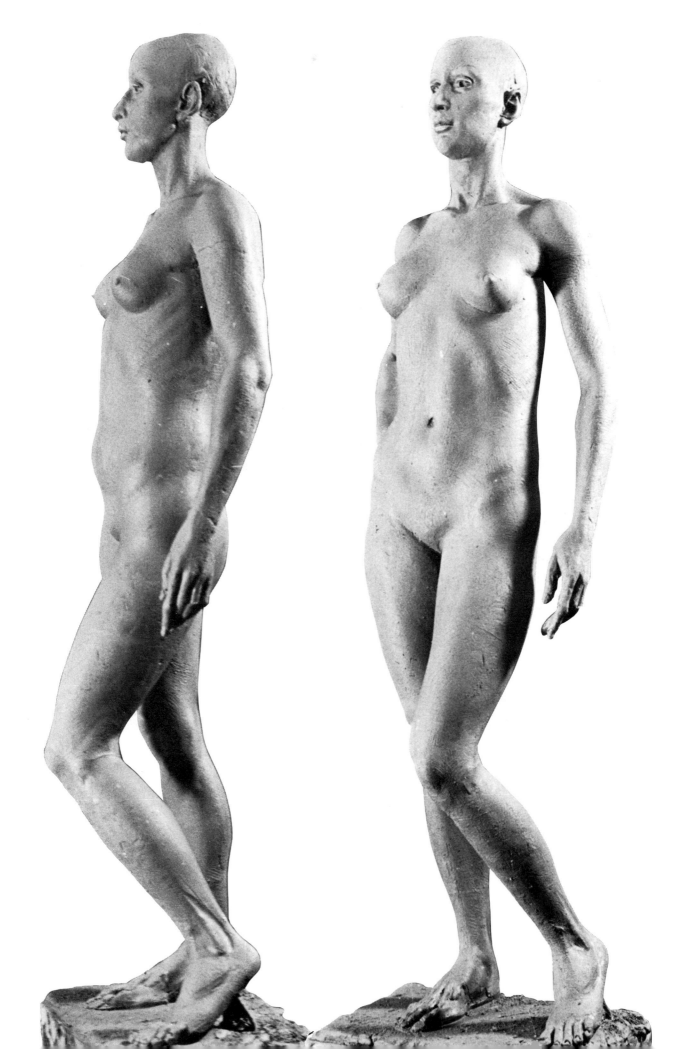

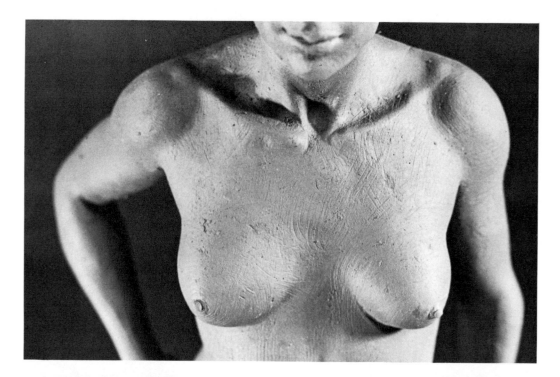

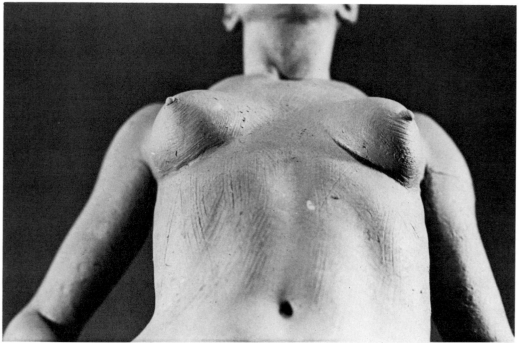

(Top) In this view of the breasts notice how they slope up into the curve of the pectorals and go into the shoulder area.

(Above) Seen from below, notice how they follow the curve of the rib cage, pointing outward at an angle from the sternum.

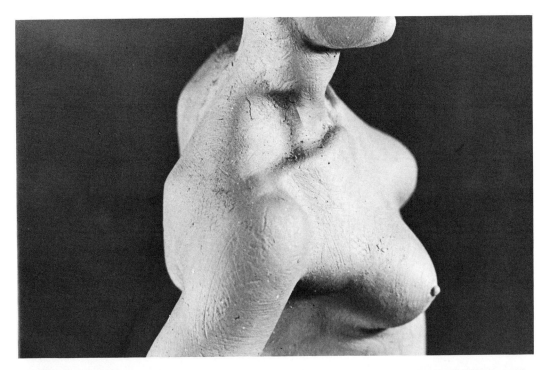

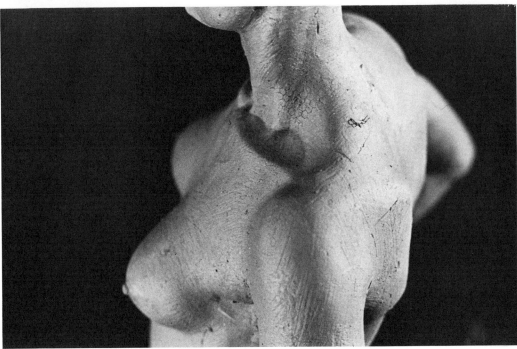

(Top) Here you can see the con-
formation of the shoulder, the curve
of the clavicle, and the breast and
pectoral as they merge at the side.

(Above) This view shows in profile
how the arm attaches to the shoulder
blade.

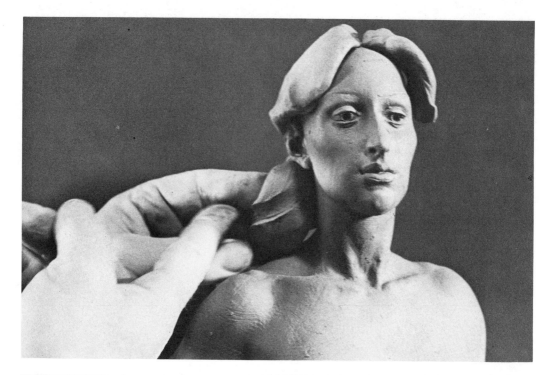

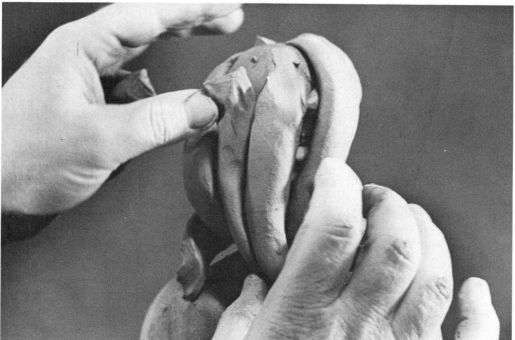

(Top) Now Lucchesi is ready for the finishing touch: putting on the hair.

(Above) He lays coils of clay on the head, pushing the clay in with his thumb.

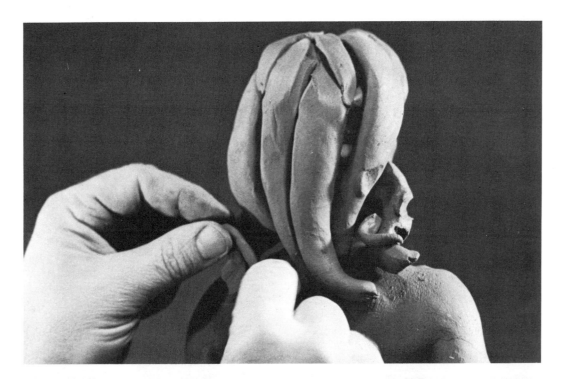

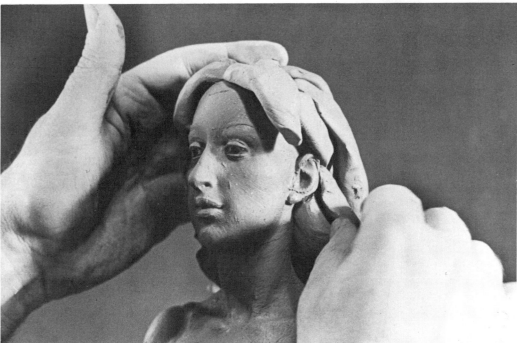

(Top) He builds up the hair mass coil by coil.

(Above) While modeling, he supports the other side of the head as he applies pressure.

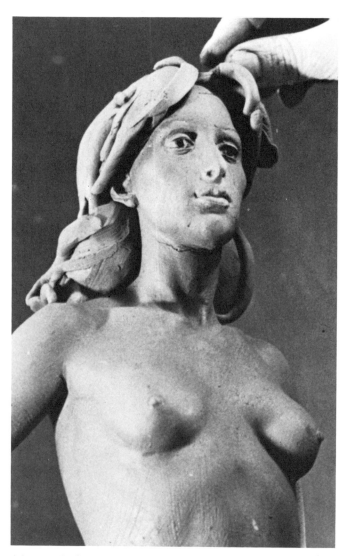

A last coil of hair is placed just
off the face.

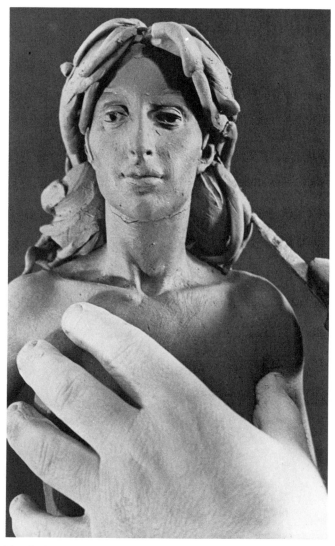

Finally he models the roughed-in hair,
blending the individual coils into uni-
fied overall masses.

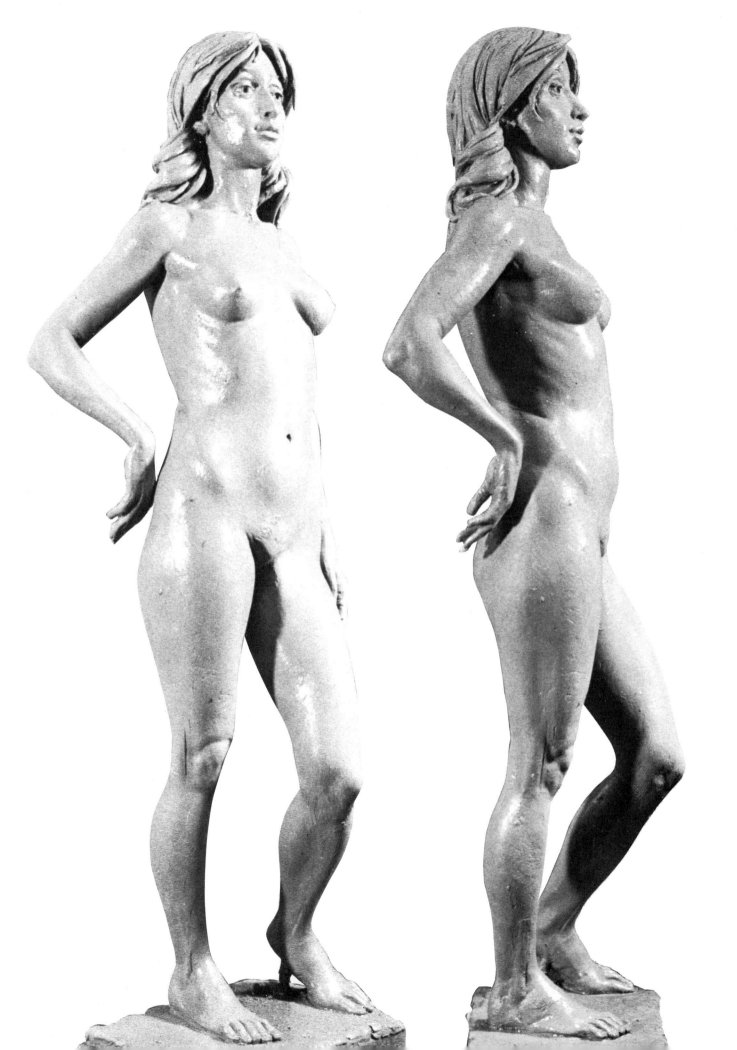

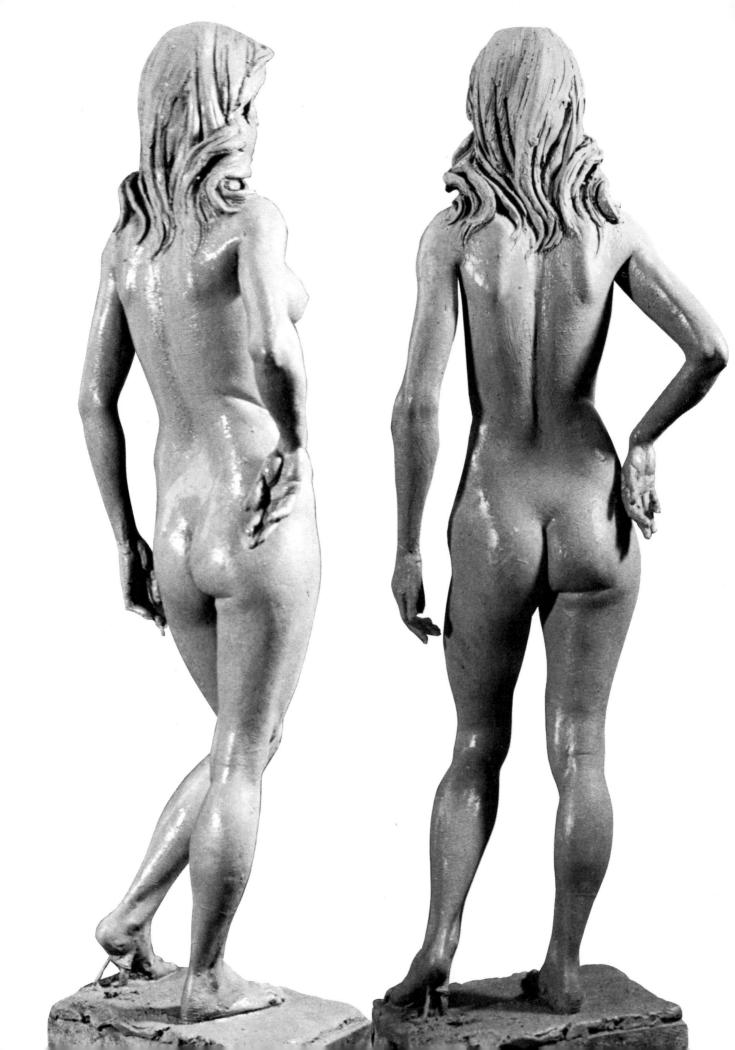

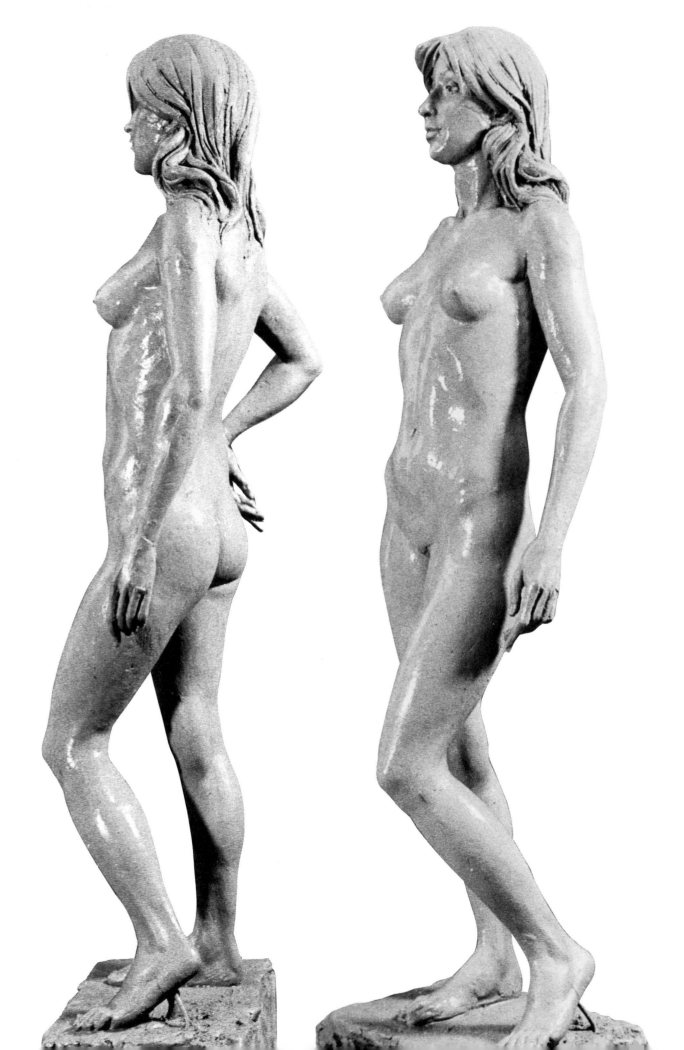

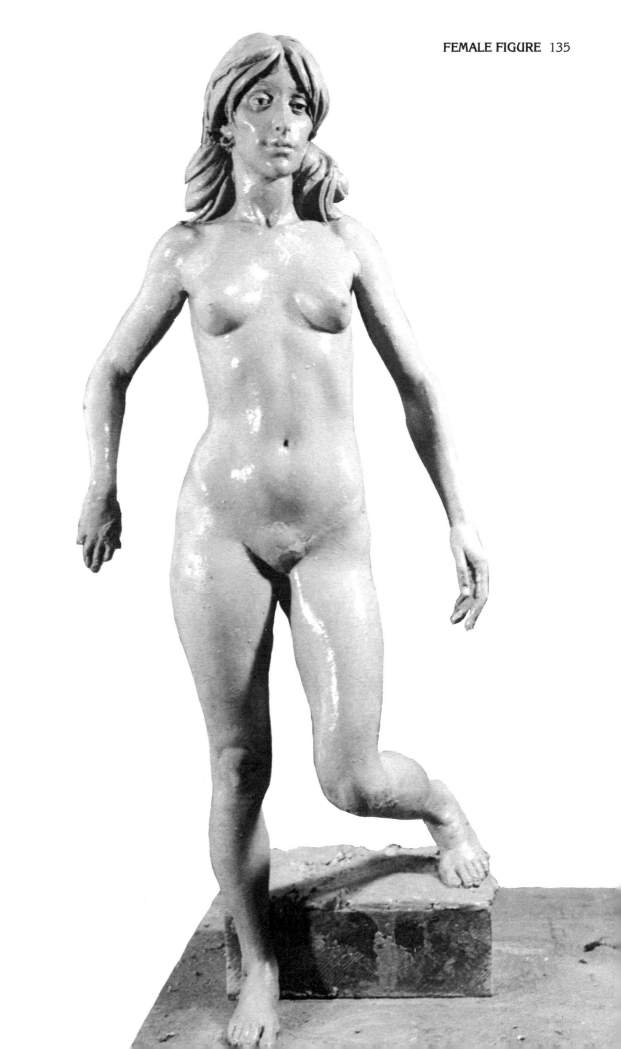

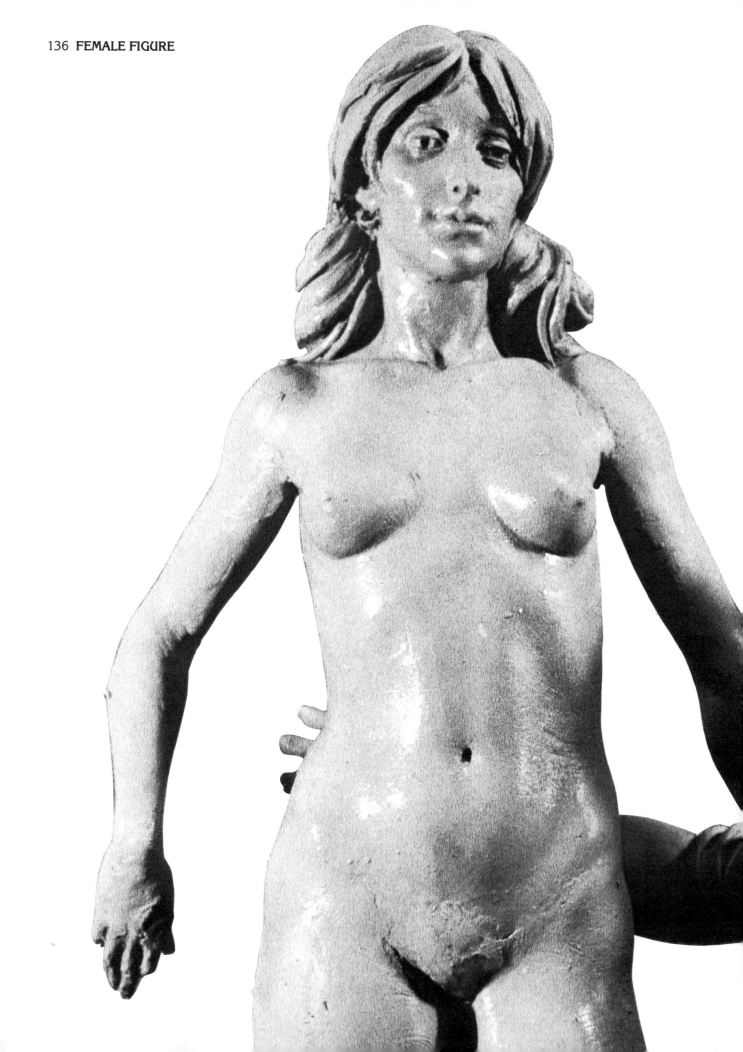

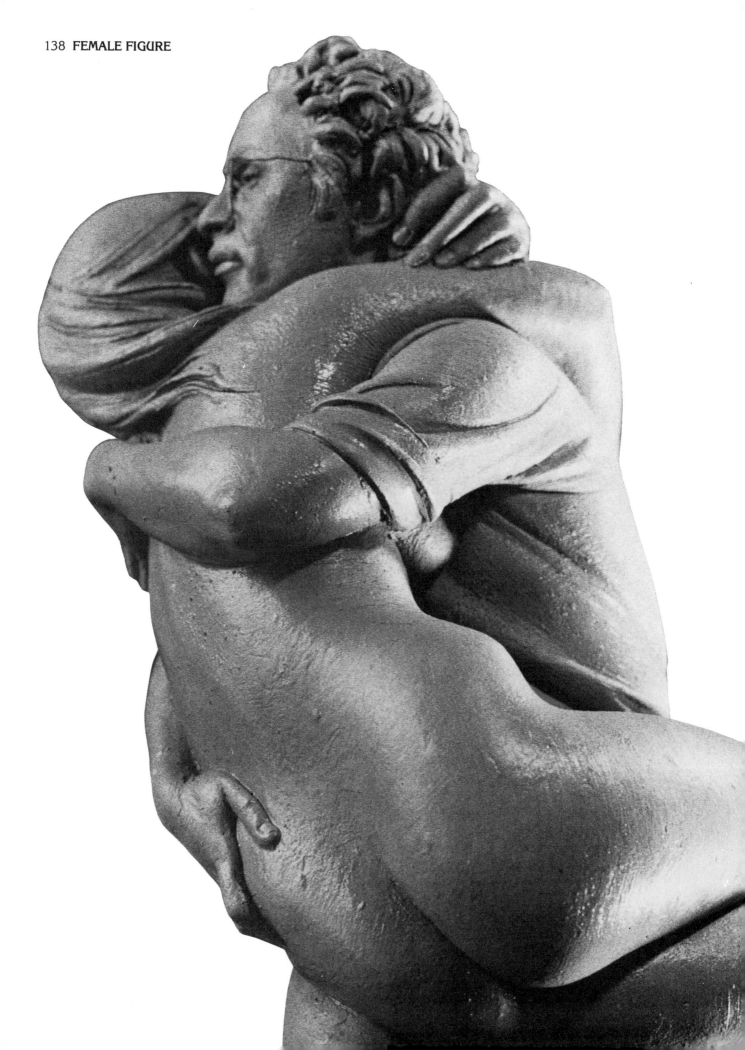

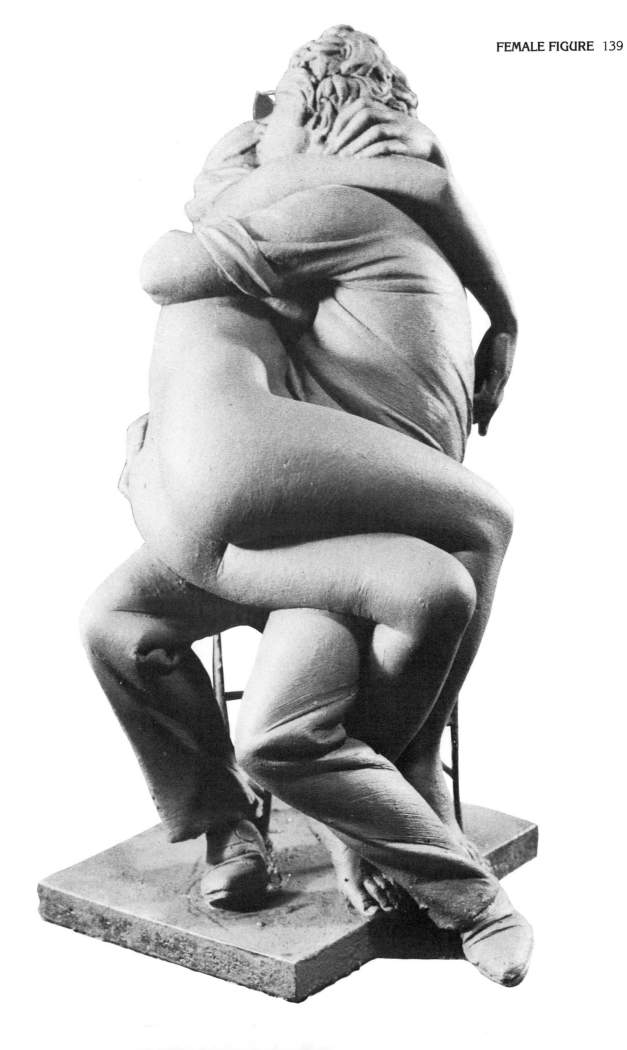

SUPPLIERS

Most of the suppliers listed here are in the New York City area. For suppliers in other parts of the country, consult your local Yellow Pages under "Pottery Equipment and Supplies," "Sculptors," and "Sculptors' Equipment and Supplies."

SCULPTURE SUPPLIES

These suppliers stock everything required by the sculptor and will send a mail-order catalog upon request:

Sculptor's Supplies, Ltd.
99 East 19 Street
New York, N.Y. 10003

Sculpture Associates, Ltd.
114 East 25 Street
New York, N.Y. 10010

Sculpture House
38 East 30 Street
New York, N.Y. 10016

Sculpture Services
9 East 19 Street
New York, N.Y. 10003

Stewart Clay Company, Inc.
P.O. Box 18
400 Jersey Avenue
New Brunswick, N.J. 08902

For clay only:

Jack D. Wolfe Company, Inc.
724 Meeker Avenue
Brooklyn, N.Y. 11222

For a complete line of pottery supplies:

Baldwin Pottery, Inc.
540 La Guardia Place
New York, N.Y. 10012

FIRING SERVICES

For firing opportunities in your area, consult your local pottery suppliers, craft schools or groups, or art departments of schools. It may take a bit of asking around before you find someone willing to fire your work for you. In the New York area two well-established firing services are:

Baldwin Pottery, Inc.
540 La Guardia Place
New York, N.Y. 10012

Studio Workshop
3 West 18 Street
New York, N.Y. 10010

BRONZE CASTING FOUNDRIES

Excalibur Bronze Sculpture Foundry
49 Bleecker Street
New York, N.Y. 10014

Joel Meisner & Company, Inc.
120 Fairchild Avenue
Plainview, N.Y. 11803

Modern Art Foundry, Inc.
18-70 41st Street
Long Island City, N.Y. 11105

Roman Bronze Works, Inc.
96-18 43rd Avenue
Corona, N.Y. 11368

CASTING AND MOUNTING

Gino Da Pietrasanta
121 East 24 Street
New York, N.Y. 10010

Rocca-Noto Sculpture Studio, Inc.
18 West 22 Street
New York, N.Y. 10010

Sculpture Associates, Ltd.
114 East 25 Street
New York, N.Y. 10010

Sculpture Casting
155 Chrystie Street
New York, N.Y. 10002

Sculpture House
38 East 30 Street
New York, N.Y. 10016

Sculpture Services
9 East 19 Street
New York, N.Y. 10003

BRITISH SUPPLIERS

Sculpture Supplies:
Alec Tiranti
21 Goodge Place
London W1

Clay Supplies:
Anchor Chemical Co., Ltd.
Clayton
Manchester M11 4SR

Pottery Equipment:
Podmore Ceramics, Ltd.
105 Minet Road
London SW9 7UH

Potclays, Ltd.
Brickkiln Lane
Etruria, Staffordshire

Harrison Meyer, Ltd.
Meir, Stoke, Staffordshire

Bronze Casting:
A and A Sculpture Castings, Ltd.
1 Faive Street
London E14

INDEX

Edited by Connie Buckley, Lydia Chen
Designed by Bob Fillie
Set in 11 point Korinna